# Frontier History Along
# IDAHO'S
# CLEARWATER RIVER

*For Nan Hughes*
*We miss you!*
*Come and see us!*
*Joann Bradbury*
*12/6/14*

# Frontier History Along IDAHO'S CLEARWATER RIVER

## PIONEERS, MINERS & LUMBERJACKS

John Bradbury

Published by The History Press
Charleston, SC 29403
www.historypress.net

Copyright © 2014 by John Bradbury
All rights reserved

*Front cover*: Load of logs at Peckham Sawmill at Fraser. *Courtesy of Marjie Johnson, Viola Molloy Collection.*
*Back cover*: Placer Mine in the Oro Fino Mining District and water wheel. *Courtesy of University of Idaho Library Special Collections and Archives, Moscow, Idaho*; Lolo Ranch. *Courtesy of Marjie Johnson, Viola Molloy Collection.*

First published 2014

Manufactured in the United States

ISBN 978.1.62619.709.1

Library of Congress Cataloging-in-Publication Data

Bradbury, John H.
Frontier history along Idaho's Clearwater River : pioneers, miners and lumberjacks / John Bradbury.
pages cm
Includes bibliographical references.
ISBN 978-1-62619-709-1
1. Clearwater River Valley (Idaho)--History. 2. Frontier and pioneer life--Idaho--Clearwater River Valley. 3. Clearwater River Valley (Idaho)--Race relations. 4. Pioneers--Idaho--Clearwater River Valley--Biography. 5. Clearwater River Valley (Idaho)--Biography. I. Title.
F752.C62B73 2014
979.6'85--dc23
2014036061

*Notice*: The information in this book is true and complete to the best of our knowledge. It is offered without guarantee on the part of the author or The History Press. The author and The History Press disclaim all liability in connection with the use of this book.

All rights reserved. No part of this book may be reproduced or transmitted in any form whatsoever without prior written permission from the publisher except in the case of brief quotations embodied in critical articles and reviews.

*To my grandparents John T. and Viola Fosster Molloy. They pioneered the Clearwater in the early days with dignity and hard work.*

# CONTENTS

Acknowledgements — 9
Introduction — 11

## 1. The Gold Rush
The Trespasser — 15
The Discovery — 18
Getting to Lewiston — 21
On to Pierce City — 24
Mining the Gold — 30
The Miners — 35
The Boomtowns — 38
The Good Times — 50

## 2. A New Territory
The Robbers and Their Shebangs — 53
Law and Order Come to Town — 55
The Quest for a New Territory — 57
The Chinese Arrive — 68
The Chinese Community — 72
The Plight of the Chinese — 78
A New Nez Perce Treaty — 80
Clouds of War — 86
War — 91
Crime and Punishment — 97

## Contents

**3. The Fight for Statehood**
| | |
|---|---|
| A False Start | 103 |
| Those Mormon Democrats | 107 |
| The Homesteaders | 119 |
| The Pioneer Towns | 127 |

**4. The New Bonanza**
| | |
|---|---|
| The Timber Barons | 137 |
| The Race to the Land Office | 141 |
| Here Come the Lumberjacks | 144 |
| The Battle for the Palouse Timber | 147 |
| Green Gold | 150 |

| | |
|---|---|
| Bibliography | 155 |
| About the Author | 159 |

# ACKNOWLEDGEMENTS

My thanks to Lewiston lawyer Mike McNichols, who suggested I write an article about Idaho's first courthouse at Pierce City for the state bar magazine. That article sparked my interest in the history of the Clearwater and prompted me to write a series of articles that the *Clearwater Tribune* graciously agreed to print to celebrate Clearwater County's centennial in 2011. I especially thank the readers of those articles who asked me when I was going to write this book. I probably wouldn't have written it without their encouragement.

Jay Kessenger, a former Latter-day Saints bishop, graciously agreed to check the accuracy of my account of the Mormon theology and history. I am very grateful. Any mistakes are due to not listening as closely as I should have.

Thanks also to Randy Smith, the reference librarian at the old Lewiston Library, who knows his stuff and understands that the ability to research through easy and regular access to the local history books and documents is an essential resource of any library worth its salt.

I am also grateful to Bernice Pullen of the Clearwater Historical Society Museum at Orofino, Mary White Romero and Laura Feucht of the Nez Perce County Historical Society Museum at Lewiston and Everett Martin of the Weippe Hilltop Heritage Museum, who were so generous with their time and helpful with documents and photographs.

My thanks also to John Vorous of Wasem's Photo Shop, who patiently walked me through the labyrinth of photo management. But for him, this book would have no photographs.

## Acknowledgements

My sister, Marjie Johnson, and my friend Jim Bradford agreed to read and critique my drafts, and the book is better for it. Its shortcomings are mine.

Finally, thanks to Lewiston historian Steve Branting for his encouragement and putting me on to The History Press.

# INTRODUCTION

The year 1860 was a perilous time in the Clearwater. It hadn't always been so. In 1806, the Nez Perce had welcomed and helped Meriwether Lewis and William Clark and their Corps of Discovery. Thirty years later, they welcomed Presbyterian missionaries Henry and Eliza Spalding to Lapwai Creek on the Clearwater River, and the Cayuse and Walla Walla tribes welcomed their colleagues Marcus and Narcissa Whitman to their mission at the mouth of Mill Creek on the Walla Walla River

As time passed, the tribes realized that their role as the host and the whites' role as guests were becoming blurred. The Spaldings were telling the Nez Perce that they must give up their hunting and gathering ways. Only as farmers could they devote the time it took to become faithful Christians. And it would be the Spaldings, not the Nez Perce, who made the rules and punished those who violated them. The Whitmans were welcoming the Oregon Trail pioneers to Fort Walla Walla as they passed through on their way to farm what had been Indian land in the Willamette Valley.

Two events triggered the blood that would soon flow. In the summer of 1847, the Oregon Trail sojourners brought a virulent strain of measles to the Cayuse and Walla Wallas. The Cayuse then tried to stop the deaths by killing the Whitmans and several other people at the mission. Several military encounters followed. By the time the virus had worked its way and the United States Army had waged its battles, about 80 percent of the Cayuse were dead.

# Introduction

Then in 1855, Washington territorial governor Isaac Stevens made it clear that the whites would determine who got what land. Stevens forced a treaty on the Nez Perce, who kept most of their traditional hunting and fishing grounds, and another treaty on the Cayuse, Palouse, Walla Walla, Umatilla and Yakima tribes, who were forced off most of their fishing and hunting grounds. When General Oliver Howard refused to renegotiate the reservation's boundaries, the Yakima War followed, and the tribes were fought into submission.

It was into this cauldron of bitterness and distrust that the unwanted and uninvited trespassers came. They were the free-spirited miners who were always moving on to the next diggings to try to make one day's dream the next day's reality. They were the first white wave into Indian Country, but they didn't want the Indians' land, they wanted gold. They would leave as soon as a more promising prospect came along.

The hardworking Chinese miners had left the grinding poverty and random cruelty in China for America with the hope of mining enough gold to be able to return to a decent life in the land of their ancestors. They would come into claims as the white miners were leaving for the next diggings. They found gold but discovered that random cruelty and violence had not been left behind. Then came the settlers who were chasing their dream of the free land promised by the Homestead Act only to find that the Nez Perce Reservation was in the way. Then came the intrigue and treachery with the stated purpose of civilizing the Indians and the real purpose of taking their land. The government then took their land. War followed.

Few people know that the plot to create the Idaho Territory was hatched at Oro Fino. The struggle for statehood lasted for twenty-seven years. That produced an entirely new cast of characters. The actors in this drama were as vividly colorful as vivid can get and took chicanery and double dealing to a whole new level.

The southern sympathizers from the border states had come west rather than fight for the Union army. They would, as the saying goes, vote for a yellow dog if it was a Democrat. The Mormons came west to escape violence, persecution and government interference in their religion, only to find in their new home that one Republican administration after another was penalizing them for practicing their faith. They were a solid Democratic voting block.

No territory would be admitted to the Union as a state unless its dominant political party was the same as the president's because the president didn't want a new state casting electoral votes for his opponent. The territorial

fathers made it their business to see that the Mormons couldn't vote so they could present Idaho as a Republican state. But there was a surprise in store for them.

Just as statehood approached, a colorful assortment of timber barons learned about the vast virgin forest in the Clearwater. The competition for the rights to the timber was fierce, but it presaged a new bonanza. This time it wasn't gold; it was trees, millions and millions of trees.

# 1
# THE GOLD RUSH

## THE TRESPASSER

Elias Davidson Pierce was a strange man—a lawyer who didn't practice law, a soldier who never fought, a miner who seldom mined and a trader who died broke. He was born in Harrison County, Virginia, in 1824. He ventured west at the age of twenty and got as far as Indiana. There he studied law with a local lawyer. Within eight months, he was qualified to practice and joined another lawyer, only to contract typhoid fever.

America was also beset by a fever, but it was a fever of a different kind. President James K. Polk had declared war on Mexico in 1844. By 1847, the Mexicans had been driven from California; General Zachary Taylor had defeated Santa Anna; and Vera Cruz had fallen to General Winfield Scott, who, a short time later, rode into a vanquished Mexico City.

Caught up in the war fever, as soon as Pierce recovered, he joined the Fifth Indiana Regiment in October 1847 and was stationed at Mexico City. As the war was winding down, the measles and diarrhea were taking a heavier toll than the fighting. As Pierce's superiors died, he was promoted to fill their shoes, so that by the time he was discharged, he was a captain.

While at Mexico City, Pierce heard about the 1848 California gold discovery. When he mustered out of the army, he headed for California. At St. Joseph, Missouri, he met three other men and they partnered up for the venture. As Pierce put it in his *Pierce Chronicle*, on May 14, 1849, "fifty-two wagons and teams, formed in a line and one hundred and fifty strong,

Elias Davidson Pierce. *Courtesy of Clearwater Historical Society.*

launched out on the great American plains for the land of promise—all in good health and fine spirits, singing, rejoicing, and making merry."

Pierce and his partners mined the Feather River that winter and at Yuba City until the partnership broke up. Pierce then teamed up with a fellow Indianan, William Good. They had figured out that supplying miners was easier and more lucrative than mining. Pierce made several trips to San Francisco for supplies that he sold to the miners at a profit.

The voters of Shasta County elected Pierce to the California legislature in 1851. He voted against legalizing gambling but for a committee report that recommended the legislature exclude Chinese from the state, that fugitive slaves be returned to their owners, that blacks could not testify against whites in any legal proceedings and that the legislative sessions should not be opened with a prayer. When the legislature adjourned, he discovered that Good had disappeared with all of the partnership money.

Broke, Pierce decided to recoup his losses by buying horses and cattle for about ten dollars a head from the Walla Walla, Cayuse and Nez Perce Indian tribes and reselling them to the miners for ten times that amount. He hired an old-time mountain man, Charles Adams, as his guide and interpreter and set out for Fort Walla Walla in August 1852. They picked up provisions for trading at Portland and then proceeded up the Columbia River to the Dalles, and from there, they hauled their goods on to Walla Walla with a pack string. They arrived at Lapwai in late October.

Pierce's sojourn with the Nez Perce went well. He learned their language and dealt with them honestly. He earned their trust. By February, he had bought 110 horses and headed back to California. Unexpectedly heavy

snows were harrowing and almost did in Pierce and his horses. Despite some close calls, he made it to Yreka.

Humbled by the hardships of the trek, Pierce went to work for the Yreka Water Company, which was building a ditch to supply miners with water. By the time the ditch was ready to go, the gold had played out, and the miners defaulted on their promises to pay. The company then defaulted on Pierce's pay. Once again, he found himself penniless. He had heard about the glittering yellow metal beyond the big bend in the Snake River from his Nez Perce friend Welaptalick; he decided to return to the Clearwater to search for gold. He left Yreka for Walla Walla in late October 1856.

Pierce arrived at Walla Walla at the peak of the Yakima, Cayuse, Palouse and Spokane tribes' battles to rid the inland northwest of the white settlers. The Cayuse had killed Marcus and Narcissa Whitman just nine years earlier. Feelings ran high; times were tense. Colonel Edward Steptoe, who had lost a battle with the Spokane tribe; renowned mountain man William Craig and his Nez Perce wife, Isabel; and Marcus Whitman's nephew, Perrin Whitman, discouraged Pierce from entering the Nez Perce Reservation. Years later, Pierce recalled Isabel Craig telling him:

> *I am Nez Perce, was raised and always lived there. That was the home of our people many years before we knew anything about the whites. A part of our people are all* [for] *war with the whites, and a portion friendly. They ordered us to leave the nation or they would kill us. And if they would kill us, and we are their people, they will also kill you.*

Deaf to their warnings, Pierce went on to Lapwai, where his old friend Welaptalick greeted him. But his restrained demeanor telegraphed that the Nez Perce sympathies lay with the Cayuse and the Yakimas. Pierce decided this was not the time to prospect on the reservation.

Pierce returned to California and did not venture back to the Clearwater until 1860. The Nez Perces' hostility to intrusions into the country reserved to them by their 1855 treaty was more heated than it had been four years earlier. Pierce decided to defy the risks and forge ahead. He and a fellow named Seth Ferrell masqueraded as traders. Each of them got a saddle horse and a pack mule, loaded their prospecting equipment and headed for the Clearwater. Welaptalick guided them without incident to the Nez Perce village of Ahsahka at the mouth of the North Fork.

At Ahsahka, however, there were some questions. The villagers asked what the prospecting equipment was for. Pierce told them it was for farming and

road construction. They were apparently appeased, and Pierce encountered no other anxious moments. On the twentieth of February, he and Ferrell proceeded up the North Fork to a sandbar, where, according to Pierce, they removed "sand and surplus soil" and "got from three to five cents to the pan." The next day, they continued twelve miles farther up the river, and at each stop, they had the same results. Pierce concluded from these finds that "there was a fountainhead or feeder further up in the mountains."

Spurred on by his find, Pierce returned to Walla Walla, determined to go to "the headwaters of the north fork prospecting." Despite the obvious risks, he managed to convince eleven men to join his venture back to the Clearwater. In an effort to avoid discovery by the Nez Perce, the party went up the Palouse River just east of where Moscow is today and headed through the woods toward the North Fork. When they reached the river, which Pierce called a "sparkling stream," they had to build a raft to cross it, and once across, the hard slog began.

As Pierce put it, it was the "most dark dense forest I ever saw…did not make more than two miles a day. In many places had to ascend to some high timbered point and climb the highest tree to survey the country in order to keep out of the deep timbered canyons." After more than a month, they came upon a fork of the Nez Perce Lolo trail, and not far from there they "camped on a nice stream of water—a beautiful place and nice surrounding country." It was there that they happened onto the gulch that gave birth to what would become Idaho.

## THE DISCOVERY

Canal Gulch—that's where the gold was, in Oro Fino Creek in the Clearwater drainage of Nez Perce country. There, on September 25, 1860, Wilbur Bassett, a member of Pierce's party, made the discovery. Pierce said they "found gold in every place in the stream, in the flats and banks and gold generally diffused from the surface to the bed rock. I never saw a party of men so much excited." Bassett, born in Connecticut, was a thirty-year-old Portland carpenter who had served in the First Regiment of the Oregon Mounted Volunteers in 1855 and 1856.

The *History of North Idaho* describes what happened next. The party returned to Walla Walla in October 1860 to publicize the find and to try to assemble a group of men to help them develop it. Few, if any, took their story

seriously, but Pierce did succeed "in enlisting the interests of thirty-three stout-hearted men." Andrew Cain, the Indian agent at Lapwai, and Colonel George Wright, in charge of Fort Walla Walla, however, opposed the party's plans. They were charged with enforcing the Nez Perce 1855 treaty rights, and they feared a war with the Nez Perce if the integrity of the treaty were breached by a glut of miners who would dig up the streams searching for their fortunes.

Contrary to Colonel Wright's orders, the party left Walla Walla for Oro Fino Creek in November 1860. Again, the *History of North Idaho* reported that "a detachment of dragoons was sent after the men, and

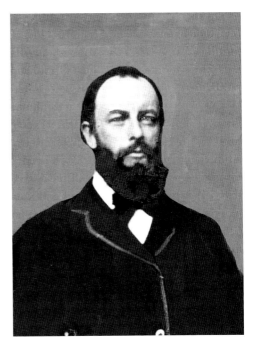

Wilbur Bassett. *Courtesy of Clearwater Historical Cociety.*

pursued them as far as the Snake River, but failed to overtake them." When the men arrived back at Oro Fino Creek, they got down to the serious business at hand. "All winter long the party wrought diligently building cabins, whipsawing lumber for sluice boxes, prospecting and the like." The men also laid out a plan for the town, which they named Pierce City.

At a January 1861 general meeting of the miners, known as "miners' meetings," the men established the Oro Fino Mining District of the Washington Territory. It extended five miles from the mouth of Quartz Creek up Oro Fino Creek and included all of the creek's tributaries. When a big discovery was made at Rhodes Creek shortly afterward, another miners' meeting incorporated it into the Oro Fino district.

The district was in Washington Territory's Shoshone County, but it had no government, so the men voted to have the mining laws that governed the California mining camps also govern the district. The laws created three types of claims. Creek claims ran 250 feet along the creek and were 150 feet wide. Gulch claims extended 150 feet along the dry gulch bed and from bluff to bluff up to a maximum of 250 feet. Hill

claims, on the other hand, went from the outcropping to the top of the hill with a 200-foot frontage.

The mining laws also authorized the miners' meetings to resolve all disputes that arose in the district. They provided that "any person or persons who may have grievances to settle—in case they cannot agree—a Miners' Meeting shall be called at which the matter shall be decided finally." The laws also excluded the "Chinese and Asiatic races and the South Pacific Ocean Islanders from the mines" and prohibited "the sale of whiskey to the Indian."

The miners elected four men to return to Walla Walla to deliver mail, replenish supplies and try again to publicize the find. They left Pierce City on snowshoes and arrived half-starved at a Nez Perce camp at the mouth of Oro Fino Creek. After recovering their strength, they trudged on to Walla Walla, where they arrived with gold dust estimated to be worth over $800. (For a rough estimate of today's value, multiply by twenty.) The men put some of the fine gold dust in baking powder cans and displayed them in the window of a Walla Walla store. The gold made believers of the doubters. It was no longer just miners' bluster.

It was not easy to get the word out. The presidential campaign of a prairie lawyer from Illinois was dominating the news. One of the first accounts of the find was in the Dalles, Oregon *Mountaineer* newspaper. It reported that the Pierce party "found gold all the way up the river, paying from 5c to 25c to the pan. Capt. Pierce and party say that the creek will pay on the bars and banks $10 to $15 per day."

Alonzo Leland, the publisher of the *Weekly Portland Times*, met Bassett when he went to Portland in October 1860 to gather supplies for the return trip to Pierce City that November. He wrote, "We are not in the habit of placing great reliance upon mining news, but the dust which Mr. Bassett exhibits, and the account he

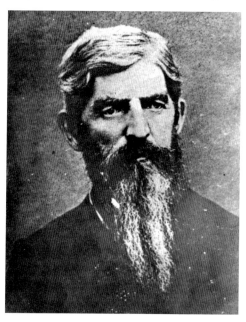

Alonzo Leland. *Courtesy of Idaho State Historical Society.*

# The Gold Rush

gives of the country, is to us more indicative of gold in paying quantities, than any discovery heretofore made in our Northern possessions." Leland's enthusiasm for the discovery was contagious. His articles were quickly picked up by other newspapers. The word was out; Idaho's first gold rush was underway.

## Getting to Lewiston

The Pierce discovery was the first major American gold rush (modest amounts of gold had been found in the Colville area) where the miners traveled from the west instead of the east. Most of the men came from California, Oregon, the Puget Sound and Canada. They walked, rode horses, drove wagons or took boats depending on their circumstances. Portland became the funnel through which the miners and merchants traveled, and from there, they went on to Walla Walla and Lewiston and then on to Oro Fino Creek and Pierce City.

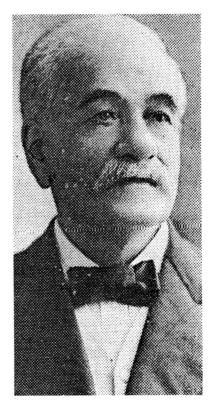

Joseph Boyd was one of the early miners at Pierce City. In William Lewis's *Reminiscences of Joseph Boyd*, Boyd described what it took to get from the Pacific Coast to Lewiston in 1861. He was born in England as the youngest of twelve children. He was orphaned at the age of six, and an older brother who worked sailing ships took him to sea with him. He eventually joined his brother as a seaman at the age of eleven on ships plying the African coastal ports and later the North and South American ports. But the life of a merchant seaman was not to be his fate.

Boyd jumped ship at San Francisco in 1857 at the age of sixteen and joined the gold rush the next year on the Fraser River in British Columbia. He then

Joseph Boyd. *Courtesy of Washington Historical Quarterly.*

worked as a miner and logger in the Puget Sound area. He heard about Pierce's discovery in early 1861 while he was logging at Port Ludlow. He left his axe and crosscut saw behind and headed for the Oro Fino diggings, as gold discoveries were called in those days.

Boyd and his comrades hired a sailboat, known as a "plunger," and sailed to Olympia, a town of about three thousand people. En route, they passed Seattle, which was then "composed of Yesler's mill and the shacks of a half dozen employees." There was no settlement at Tacoma. From Olympia, they took a spring wagon stage to Monticello, where they caught a small steamer that carried them down the Cowlitz River and up the Columbia and the Willamette Rivers to Portland.

Portland was a robust community of about four thousand inhabitants, and the gold rush added to the excitement. The Oregon Steam Transportation Company was hauling the deluge of passengers and freight as far up the rivers as it could. Boyd recounted an observer's description of the hustle and bustle of the docks: "Loaded drays used to stand in lines half a mile long, unloading at night freight to go in the morning that involved a fortune." In the midst of all this activity, Boyd and his pals got passage on a river sailboat—a flatboat schooner—up the Columbia to the Cascades.

At the Cascades, a rail tram carried the freight around the rapids, but the passengers had to hike three miles with their belongings on their backs to catch a steamboat that took them as far as the Dalles. From there, the men took a stage to Celilo, where the stern-wheeler *Colonel Wright* took them as far as Walula. There was not a stage at Walula when the ship arrived, so, as Boyd put it, "the five of us had to shoulder our packs and blankets and travel to Walla Walla on foot." When they got to Walla Walla, they found it was "filled with miners and men going to the Oro Fino placer

Ephraim Baughman. *Courtesy of Nez Perce County Historical Society, 83-30-3.*

# The Gold Rush

mines." Tired of packing their possessions, the men bought a Cayuse pony as a packhorse and hiked on to the big bend in the river.

Although the *Colonel Wright* carried Boyd and the freight only as far as Walula, it had earlier made it as far up the river as the big bend in the Snake River (Lewiston) in the early spring of 1861. Its captain, Ephraim Baughman, was born in Illinois in 1835 and, at the age of sixteen, had driven an ox team to California. Tired of mining, he moved to Oregon and started his sailing career as a fireman and worked his way up through the ranks to captain. He later sailed the *Tenino*, which regularly called at Lewiston.

Baughman described the *Colonel Wright* as "a vessel with some fifty tons burden, about 125 feet in length, filled up with good machinery and well supplied with necessary equipments." The crew included the engineer, assistant engineer, two firemen, a steward and assistant steward, the purser, the cook and six deck hands. It departed Celilo Falls on its first trip to the big bend on the tenth of May. Among those aboard the *Colonel Wright* when it departed was Portland merchant Seth Slater and some ten to fifteen tons of freight he had brought with him to supply the new gold rush.

Baughman sailed the vessel only during the day because of the shallow water and frequent rapids, reefs and shoals he had to navigate. He said when the *Colonel Wright* rounded the big bend, they "were met by the rushing waters of a stream clear as crystal and broad enough to be classed as a river." And so began the journey up the Clearwater River. Because of the ship's small size and modest power, the crew had to winch it over several rapids. And then, about thirty miles up the river, they encountered Big Eddy, near present-day Lenore.

Baughman described the ordeal: "Twice we lined [winched] her and moved slowly up stream, but the vessel did not have power enough to keep herself in the channel, so we finally gave it up for the time being, came on shore and began making explorations." The conditions farther up the river turned out to be worse. As a result, Big Eddy was the end of the line. Slater's freight was offloaded there. Slater set up a tent camp, thinking it would become the jumping-off point for supplying the miners. The one-man operation called Slaterville sported a general store and a large saloon. Half of the saloon roof was a red blanket, and the other half was a blue one. "WHISKEY" was printed in large letters in charcoal on the canvas walls.

On the *Colonel Wright*'s return trip to the big bend, there was a message that Slater wanted the vessel to bring him and his freight back to the big bend so he could be where the trails led to the mines. The *History of North Idaho* recounts that the vessel retrieved "Slater and his goods, and brought

them safely to the shores of the Snake, where Slater again pitched his tent. Soon he had opened near the confluence of the rivers the first store in what is now Lewiston and perhaps the first in the Clearwater country." Boyd said when he arrived there was nothing but "the tents of a few miners like ourselves, and two stores in tents, one owned by a man named Titus," and that "Slater was the other early merchant there." Boyd called the settlement "Ragtown" because of "the many tents which soon acquired a very dirty and dilapidated appearance." Tents were common because permanent buildings were banned within the Nez Perce Reservation.

## On to Pierce City

The determined sojourners from Lewiston to Pierce City encountered what today would seem like insurmountable physical and human perils. The Washington territorial legislature funded a road, but it was little more than a slightly improved Indian trail. The road went through the William Caldwell ranch (near what is now Culdesac), on to Cold Springs at the head of Big Canyon Creek (near what is now Craigmont), on to the "Holes" (near what was Mohler) and then on to the Clearwater River about a quarter mile upriver from the present town of Greer. Early day stockman John T. Molloy said the freight was hauled over this "road" by "pack trains consisting of fifty or more mules to the train followed later by ox teams consisting of seven to ten yokes of oxen to the wagon with trail wagons in the rear."

Because the ravines were so deep and the breaks of the Clearwater River were so steep, the trails and roads could only follow the ridges down to and out of the river. The ridges in some places were almost perpendicular. Large logs were tied to the freight wagon axles to slow their rate of descent so they would not run over the oxen, horses and mules in front of them. An enterprising youth at Greer was paid to pour water on the wagons' sizzling hot brakes to prevent the wagons from bursting into flames. Once the travelers and the freight reached the river, the next challenge was to cross it.

William Craig, Tom Beall and Jacob Schultz turned the challenge into an opportunity. They built a ferry at Greer and maintained a house where the travelers could lay over to eat and rest, known as a stage stand. The stage stand provided both food and lodging for travelers, and there was a cabin on the west side of the river for the operator of the ferry to also stay if needed.

When it comes to mountain men, Craig was the real thing. He was born in Virginia in 1807. Lin Tull Cannell, in her book *The Intermediary: William Craig among the Nez Perce*, describes Craig as a strapping redheaded, blue-eyed, six-foot-tall young man who may have fled Virginia following a fight over a woman in which the other man was killed. During the first twenty years of his life, he was the consummate mountain man and trapper. When the fur trade collapsed in 1840, he and his Nez Perce wife, Isabel, settled at Lapwai Creek. Fluent in the Nez Perce language, he was the Nez Perce interpreter during the 1855 treaty negotiations with territorial governor Isaac Stevens.

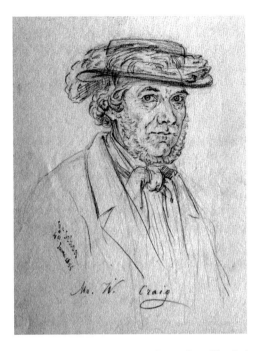

William Craig. *Courtesy of Washington State Historical Society.*

Thomas Beall was born in Washington, D.C., in 1834, the son of an army officer who served in the Florida and Mexican wars and the grandson of the army officer who commanded Fort McHenry during the War of 1812. He attended college in Missouri while his father commanded Fort Leavenworth. He went to California in 1854 and in 1860 helped build the Indian Agency at Lapwai, where he and Craig became friends.

William Goulder, an early Pierce City miner and a friend of Jake Schultz, described Schultz in his remarkable book

Thomas Beall. *Courtesy of Nez Perce County Historical Society, Jeanne Wrightet Weber Collection.*

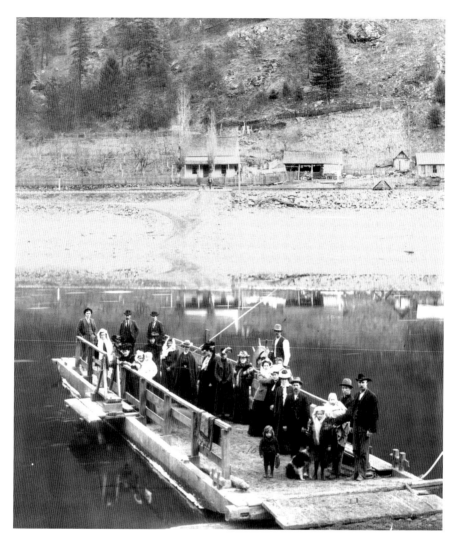

Greer Ferry. *Courtesy of Clearwater Historical Society.*

*Reminiscences of a Pioneer* as a sturdy Pennsylvanian who was intelligent, affable and "always cheerful and entertaining." Given his outgoing nature, he seldom turned down a glass of wine and was always ready for a game of draw poker. Schultz was the one who usually ran the ferry, and he "kept a good house and maintained an excellent ferry, where a traveler was always sure of a good meal and bed and a safe transit across the river."

The ferry toll was $1.50 for a freight wagon and animals; $1.50 for a pleasure wagon and two horses and $0.25 for each additional horse; $0.75

# The Gold Rush

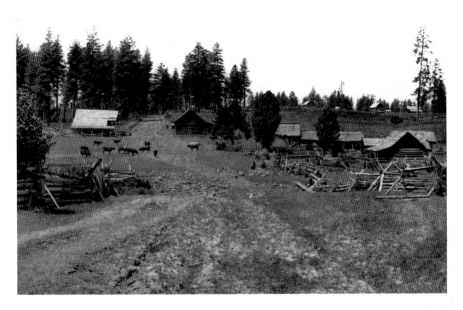

Lolo Ranch. *Courtesy of Marjie Johnson, Viola Molloy Collection.*

for a wagon or carriage with one horse; $0.50 for a man and his horse and $0.50 for each additional animal or packhorse; $0.25 for a passenger on foot; $0.15 for sheep, goats and hogs; and $0.10 for all other animals.

Once up on the prairie, the first resting place was the Texas Ranch, a few miles from the top of the hill that was run by a man named "Tex." It was a hospitable place where packers and others could stop over to rest themselves and their animals. Layne Gellner Spencer recounts in her book *And Five Were Hanged* that "for two-bits a traveler could buy a glass of Hell-fire whiskey and for four-bits a plate of bacon and beans."

Young Boyd arrived at the Texas Ranch with a pack train on its way to Oro Fino, a second mining town that had sprouted up a mile and a half south of Pierce City. He said the "packers had plenty of grub and liquor which they hospitably shared with us and which we greatly appreciated." Early day stockmen Martin Mauli, a Swiss immigrant, and Peter Hourcade, a French immigrant, bought the ranch in the early sixties and continued the friendly tradition as the Lolo Ranch. All travelers were welcome.

The next popular place for rest and food and for pasture and hay was the Poujade Ranch, which was sometimes referred to as the Ford's Creek Station.

William Goulder. *From* Reminiscences, *by W.A. Goulder.*

It was close to what is now Weippe and was owned by Theodore Poujade, his wife and their young son, Ted. It was especially busy during the winter because the snow was often so deep people had to snowshoe from there to Pierce City.

Goulder said the "ranch was far from being a lonely place, as every day brought its quota of snow-trampers, journeying to and from Oro Fino. The [pony] express man came every week with horses as far as the ranch, where he was obliged to leave his animal and make the rest of the trip in on snowshoes." To get the supplies through the fifteen miles of snow from the ranch to Pierce City, "men were employed at 30 cents per pound to pack them on their backs. Strong men would make this trip in a day, carrying all the way from 60 to 100 pounds."

Goulder was a Virginian who had traveled the Oregon Trail in 1845 by way of Soda Springs and Fort Hall to the Willamette Valley. He met and became friends with the Poujades when they farmed there. Goulder joined the Oro Fino gold rush in early 1861. He would spend several years in Oro Fino and Pierce City, where he was elected to the second session of the Idaho territorial legislature. He later moved to Boise, where he became an editor of the *Idaho Statesman.*

The winter of 1861–62 was brutal, and it was taking a huge toll. The Nez Perce could not remember having experienced a worse winter. There was snow by the first of October. Boyd said it was so cold that the thermometers broke and forty-seven feet of snow fell during that winter, which later compacted into five feet of almost solid ice. People who lagged behind or got off the trail froze to death between stopovers.

There was little the Poujades could do about the harsh winter, but Mrs. Poujade found that she could do something about the snow blindness that became increasingly common as the winter progressed. She concocted a

poultice from tea leaves and applied it to the sufferers' ailing eyes. She is also the person who figured out how to treat the outbreak of scurvy in Pierce City and Oro Fino.

Early on, the deep snow prevented the packers and freight wagons from making it beyond the Poujade Ranch. A packer who was stuck with several sacks of potatoes buried them at the ranch so they wouldn't freeze. Before long, more than five feet of snow had fallen; the temperature was thirty degrees below zero, and it was getting worse. The lack of fruits and vegetables caused an onset of scurvy throughout the mining district. The Poujades dug up the potatoes, and men hauled them by snowshoes into Pierce City and Oro Fino. There, the raw potatoes were sliced and soaked in vinegar. They worked a cure. Goulder credited the Poujades with saving many lives during that fateful winter.

Spencer described the two stops along the way where fresh food could be bought. Grasshopper Jim Clark's ranch was on down the road from the Poujades'. Clark sold the vegetables and chickens. He earned his nickname from his belief that his chickens would not have made it if it had not been for the grasshoppers. Truth be known, his vegetables probably would not have made it if it had not been for the chickens eating the grasshoppers.

The other food stop was Dave Mulkey's Milk Ranch, which was seven or eight miles south of Pierce. Mulkey sold produce and took in travelers, but as its name implies, it was known primarily for its milk and butter. It was quite an operation for its time. When the ranch changed hands in September 1861, twenty-five cows, eighteen calves and a bull were included in the deal. One wonders where Mulkey got the feed to get them through the winter.

Steep ridges, forbidding ravines, narrow trails and deep snow were only some of the perils. Humans played their parts as well. The *History of North Idaho* described the risks. William Rowland and George Law were known horse thieves who plied their trade on the Camas Prairie. A packer named Hypolite was murdered, and his pack train and $500 worth of gold dust were hijacked. Robbers along the trail separated George Noble from one hundred pounds—yes, pounds, not ounces—of gold while he was on his way to Pierce City.

Early day packer Enos William charged four dollars an ounce to pack gold from Pierce City to Lewiston. But he quit because the "renegades robbing people [had] made the packing of gold too dangerous…Looks like all the jail doors have been opened in the states and all the bad men come here." Despite all these obstacles, prospectors and everyone following in their wake continued to pour into the Oro Fino Mining District.

The *History of North Idaho* reported that by April 1861, there were three hundred people; by May, there were nine hundred; and by July, "the creeks were swarming with people." Eventually that year, the population may have reached as many as seven thousand people, of whom perhaps "only two thousand were real miners." That was a lot of people for that time, which was made clear during the congressional election of 1861, when Shoshone County cast the most votes in the Washington Territory, outvoting the coastal towns of Olympia and Vancouver. And they were a tough breed of hardy souls.

## Mining the Gold

Mining was grueling work. The miners prospected for gold with iron gold pans. The worth of a claim was gauged by the value of the gold found in a pan, couched in terms of so many cents to the pan. The price of gold at that

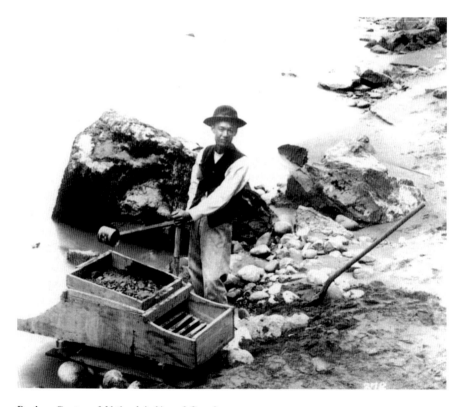

Rocker. *Courtesy of National Archives of Canada.*

time was fifteen dollars an ounce. While not common in the Oro Fino District, individual miners also used a rocker, which was sometimes called a cradle. It was a rectangular wooden box with an upright handle that could be used to shake the pay dirt while pouring water over the top that would wash the dirt onto a short chute with transverse slats or ribs that were called riffles. The current would wash away the dirt, and the gold would sink down behind the riffles. It worked on the same principle as a gold pan, but it took a lot less work.

If the claim was judged to be worth the cost and labor, most miners mined the gold with sluice boxes, which were long, narrow wooden chutes with riffles on the bottom. On the creek claims, gold was commonly found at the bottom of rapids in still portions of the stream where the current could not carry it any farther. Claims, of course, varied, but a typical claim would have two or three feet of overburden, which the miners would remove with shovels, picks and wheelbarrows, and then there would be between three and eight feet of sand and gravel pay dirt over the top of the bedrock of decomposed granite and quartz. A reporter from the San Francisco *Bulletin* visited the diggings in February 1861 and described the pay dirt:

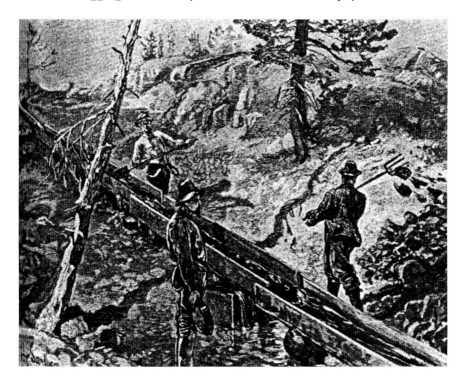

Ground sluicing. *Courtesy of University of Idaho Library, Special Collections and Archives, Moscow, Idaho.*

# Frontier History Along Idaho's Clearwater River

*The principal gravel is pure white quartz, about three feet deep in pay dirt, on a soft rotten white rock. The dirt is generally red, sometimes of a bluish cast. Much black sand appears in its washing, and about one half pound per pan is readily obtained.*

    Miners would clear an area along the stream about forty feet long and twelve feet wide, which they called the pit. Within the pits, men dug troughs at a grade steep enough so that when the sluice boxes were installed, the current would be strong enough to separate the gold from the gravel. They then built a dam above the pit to collect the water and attached water wheels to feed the water to the boxes.

    Two men with picks and shovels stood in the pit and loaded sand and gravel into the boxes. Another man removed the heavier rock that the water could not move from the box with a placer fork. A fourth man shoveled the rock and sand collecting at the mouth of the box (called tailings) as far out of the pit as he could throw it. During this process, the very fine but much heavier gold, called "flour gold," would sink to the bottom of the boxes and lodge behind the riffles. Because the gold was so fine, at intervals during the day, the claim owner or the boss put quicksilver in the riffles to keep the gold where it was lodged. The gold dust adhered to the quicksilver and formed an amalgam that could be easily removed from the box. Coarser gold and nuggets were later found in Oro Grande Creek where quicksilver was not needed. This method worked well for the creek claims where the water came right to the claim. It was not as simple for the hill and gulch claims.

    Gold on hill and gulch claims was usually found on the side of the hill or the face of a gulch, so water had to be brought to them. That required ditches big enough to carry the water needed to work the claims. Israel Cowen and Cyrus T. Nelson had the shrewd insight to figure out that water claims might be more valuable than gold claims. Each man acquired legal rights to the water they would supply and then dug a major ditch to carry that water to the individual claims. The ditches were two feet deep, two feet wide at the bottom and three feet wide at the top. Nelson, who was a successful Walla Walla rancher on Dry Creek, built his ditch along the ridge that separated Rhodes Creek and Canal Gulch. Cowen built his ditches along both sides of Oro Fino Creek.

    Smaller ditches, called races, would then carry water from the major ditch to the claims. Once the miners got the water to the claims, they would "ground sluice." Dr. Darby Stapp described ground sluicing in his doctoral dissertation, "The Historic Ethnography of a Chinese Mining Community in Idaho":

# The Gold Rush

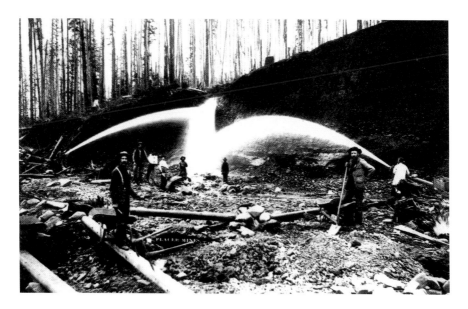

Ground sluicing. *Courtesy of University of Idaho Library, Special Collections and Archives, Moscow, Idaho.*

*Ground sluicing was greatly improved by hydraulic methods, which used high-pressure streams of water to undercut gravel banks, causing cave-ins. To produce the high-pressure stream of water, a head box was built at the water source, usually a ditch. The water was then transported downslope through canvas hoses or riveted steel pipe to the mine where it passed through pipes of decreasing diameter, further increasing the pressure. Finally, it passed through a nozzle, commonly referred to as a "little giant," from which the stream could be directed. The water was then used to wash the auriferous deposits* [pay dirt] *into the gold sluices.*

The sluice box was placed below the pay dirt so when the strong jet of water was aimed at it, it fell directly into the box so it would not have to be shoveled in. In the gulches, there was the risk of the ground above the pay dirt caving in, and on the hill claims, large trees often had to be removed before the operation could start.

Boyd described the five weeks it took for him and his two Norwegian partners, a fellow named Swanson and Ole Gullingsrud, to dig a three-mile ditch that would deliver one hundred miners inches of water to their hill claim above Rhodes Creek:

*We were out before sunrise, and started work by starlight, and worked until after sunset and went home by starlight. We worked all day, every day, rain or shine and were often wet to the skin ten minutes after we had left our camp, and kept going in wet clothing all day. One partner went ahead with a broad axe or mattock cutting the brush, kinnikinnick, and sod and turning it over down the hill; the next partner followed taking a spadeful or two out, and I followed finishing up the ditch.*

Once the ditch was dug, Boyd got up at five o'clock in the morning and walked the three miles to the head of the ditch and turned the water into the ditch from the impounding dam that had collected it during the night, then walked back three miles for breakfast. After washing gold all day, he repeated the three-mile trip to turn the water off so it would collect during the night. Only then did he return to his cabin and call it a day.

The creek claims were usually worked year-round because the water was always available. The hill and gulch claims often required more water, especially for the ground sluicing. As a result, the work on these claims was seasonal because the major ditches depended on the spring snowmelt and the fall rains to supply them with enough water to support the claims. The *Idaho Tri-Weekly Statesman*'s Pierce City reporter related the importance of the water to work:

*The long drought of summer and early autumn, which was so trying to our miners and merchants, has at length given way to a season of rejoicing. Miners, like young ducks, revel in humidity. Copious*

Ole Gullingsrud. *Courtesy of Clearwater Historical Society.*

> *and grateful showers have descended almost incessantly for the past ten days, filling the ditches and setting everybody to work with a will to make the most of the "fall run."*

That is not to say the idle times were wasted. As Dr. Stapp observed, the "most common activity before mining commenced and after mining ended was the preparation of the claim. By removing vegetation, clearing off overburden, digging races, building sluices, etc., the miners could assure that once the water did arrive, they could make maximum use of their time."

## The Miners

Men working their own claims could make up to twenty-five dollars, or about two ounces of gold, a day. It was not uncommon for hired miners to make four or five dollars a day and get their board. On a good claim, they could earn up to ten. During the nonwinter months that it was possible to mine, some operators ran a day shift and a night shift.

A six-day week, eleven hours a day, was the rule for hired miners. On Saturday night, a final "cleanup" of the operation for the week was called. Boyd said their cleanups averaged $400 to $500 a week. The miners were then paid in gold dust, which was the accepted medium of exchange. All the mine owners and merchants had gold scales, and all the miners had buckskin pouches for their gold. Cash registers, banks and greenbacks were for another day.

Miners were nomads at heart. Idaho historian Merrill Beal described their nomadic trait: "A miner's wanderlust stirred his blood mightily, and especially so in the spring. The call of new and rich diggings, even though deceptive, was seldom resisted." The Portland *Oregonian* waxed almost poetically about their wont to roam: "What a clover field is to a steer, the sky to a lark, a mud hole to a hog, such are new diggings to a miner. Feed him on a succession of new diggings and his youth would be perennial."

No miner more typified that trait than young Patrick Gaffney. He was born in 1835 in Sligo, Ireland, where he worked in a brewery as a youth. Just when and where he landed in the United States is not known, but in 1858, he went to California, where he worked in the gold mines. In early 1861, he heard about the Oro Fino diggings and journeyed to Pierce City, where he mined gold for only a few months. He was a typical restless prospector.

# Frontier History Along Idaho's Clearwater River

Patrick Gaffney. *Courtesy of Virginia Gaffney Bird.*

As soon as gold was discovered in Florence in late 1861, Gaffney went there. As soon as gold was discovered in Virginia City in the summer of 1862, he went there. From there, he went on to what became Wyoming, where he was one of the original explorers of Yellowstone Park. After that venture, he returned to the California mines. Before long, he was off to Honduras looking for gold, and then he was back in California, where he mined on Rattlesnake Creek in the Fort Jones area. It was during this trip back to California that he married Bridget Gaffney, who had the same surname but was not related.

Bridget was a seamstress who had emigrated from Sligo to Boston in 1852 and had eventually found her way to San Francisco. Sailing ships were not reputed for treating immigrant passengers kindly; crossing the tropical isthmus was fraught even more with yellow fever and malaria. When she made it to San Francisco, she married Patrick in January 1866. Their first child, Francis, known as Frank, was born there in October of that year.

In late 1867, Bridget and Patrick and their seven-month-old infant started their journey north. They took a steamboat as far as the Dalles and continued on from there on horseback. The family arrived in Pierce City that fall and settled in Barclay Gulch. Patrick continued mining and owned a butcher shop in Pierce City. At the same time, Bridget was busy bearing and rearing her children. John was born in 1868; Thomas, who died as an infant, was born in 1870; William in 1873; Mary in 1874; and Robert in 1876. Despite his nomadic youth, Patrick spent the rest of his life in Clearwater country.

One of the most colorful and successful miners was William Rhodes, known as "Black Bill" or "Billy." Rhodes was a mulatto. It is not known if he started

life as a slave or free. What is known is that in 1848 he traveled with a family named Jones from Missouri to California, where he prospected and mined in the Scott River area. Rhodes's friend Israel Cowen said he had made and lost a fortune as a Forty-Niner in California before he came to Oro Fino Creek. He is thought to have been one of the miners recruited by Pierce at Walla Walla for his return trek to Pierce City in November 1860.

Rhodes made a second fortune soon after his arrival at the Oro Fino diggings when he discovered the district's richest gold deposit a mile or so from Pierce City on Rhodes Creek, which now bears his name.

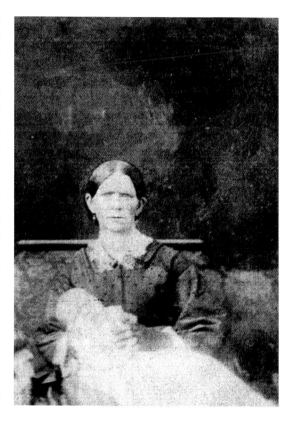

Bridget Gaffney. *Courtesy of Virginia Gaffney Bird.*

A contemporary of Rhodes wrote that by November 1861, he had netted $20,000 that season. Levi Ankeny, an early merchant, wrote that Rhodes made about $80,000 during the 1861 and 1862 mining seasons. That would be more than $1 million in today's money. He apparently was a big spender with a big heart. Ankeny described him as a "universal spendthrift, not a gambler, but he would give money to anyone who needed it."

After frittering away his second fortune, Rhodes went to Arizona, where he staked a quartz claim that he sold for $75,000. After he blew that fortune, he returned to Oro Fino. Sadly, this man who enjoyed the affection of so many and was known for his generosity to anyone in need was broke when he died of dysentery during the harsh winter of 1888. But he died an optimist. He had just been grubstaked to look for the "mother lode" in the Blacklead Mountain area near the Idaho-Montana line. The snow was so deep that his compatriots had to bury him in the

snow twice before they could get to solid ground to give him a decent farewell.

Billy Rhodes was not the only one to profit from the mines. Consulting engineers at the time estimated the value of the gold production from the Oro Fino Mining District in those days' dollars at $1,000,000 in 1861, $800,000 in 1862, $600,000 in 1863, $400,000 in 1864, $300,000 in 1865 and $300,000 in 1866. Boyd estimated the value of all of the gold taken from the district over time at $150,000,000.

## The Boomtowns

Joe Boyd said the Oro Fino Mining District "diggings extended down Oro Fino Creek four or five miles, and up Rhodes and Canal Gulches eight or ten miles on both sides and up the many gulches running into them, including Shanghai Gulch, Humbug Gulch, Bartley's [Barclay's] Gulch and Mill Creek." Pierce City was the commercial center for Canal Gulch and the lower part of Oro Fino Creek. Oro Fino served Rhodes Gulch and the upper part of Oro Fino Creek. At its peak, it was bigger than Pierce City. Its survival was doomed, however, because it was located on the rich placer grounds that Billy Rhodes had discovered. It turned out that what was under the ground was worth more than what was on top. By the time the miners had had their way, there were not even enough structures left to qualify it as a ghost town. But it was quite a town while it lasted.

The district was bursting with activity. The *History of North Idaho* noted that the five thousand inhabitants who were not "real miners" were doing "things like cutting trees, sawing boards for building [sluice] boxes, running stores, playing cards, selling and drinking whiskey, driving teams, digging ditches, sometimes digging graves." Houses were built of hand-hewn logs and shake roofs because pine trees were plentiful and free for the taking, unlike lumber, which was expensive.

The lumber was whipsawed by hand. Joe Boyd said that to whipsaw lumber, "one had to dig a pit, and build a staging over it; then cut and roll down the logs, which are first squared up by sawing off the slabs on four sides; then laid out by rule for sawing into boards." A pair of sawyers could turn out two hundred board feet a day and make twenty dollars or more a day. Given the elbow grease needed to saw a board, it is little wonder that the miners called the whipsaw operations arm-strong sawmills.

# The Gold Rush

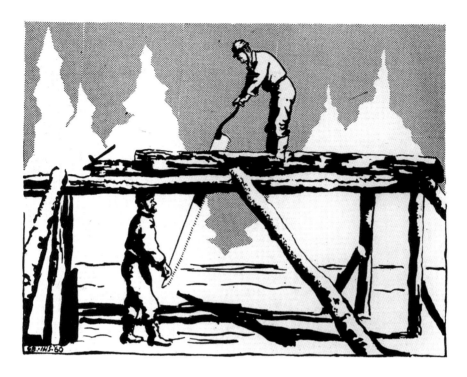

Whipsaw. *Courtesy of Idaho State University, Idaho Yesterdays.*

The need for commercial buildings with more than tent walls and roofs and the constant demand for sluice boxes and water wheels prompted local merchants to import a sawmill, known as the Starr Mill. It, together with the Pierce City Sawmill, which was probably owned by David Fraser, a local merchant and political figure, was soon supplying the district with lumber. Before long, commercial buildings were popping up like mushrooms and the gulches and creeks were dotted with sluice boxes.

D.F. Leonard ran a gambling joint in Pierce City. There were four general stores: Canfields, Stanford Capps and Company, the Benjamin F. Yantis Store and George Reed's Store. Boardinghouses and hotels included the Luna House at Canal Gulch, the City Hotel and the Pioneer Hotel. Also gracing the town were the Diana Saloon, the Keith and Reed Saloon, the National Saloon and the American Saloon. There were also, of course, blacksmith shops, livery stables, feed barns and other vendors and artisans.

One of the earliest successful Pierce City merchants was Benjamin Franklin "Frank" Yantis. Yantis was born in Kentucky in 1807, and as a young man, he moved to Missouri, where he was a superior court judge. In

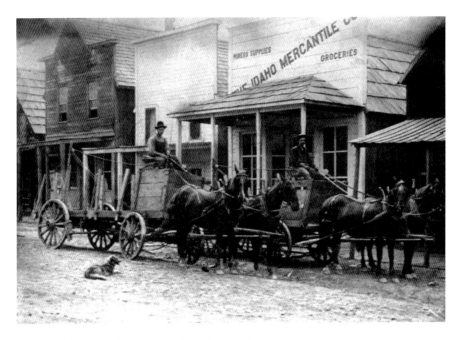

Stagecoach in Pierce City. *Courtesy of* Lewiston Tribune.

the early 1850s, he and his wife joined a wagon train going to Oregon. His wife and many others died during the trip, probably from cholera, which was a scourge during those cross-country treks. Yantis ended up in Olympia, where he ran a stage line and in 1854 was elected to the first Washington Territorial Council (Senate). In 1861, he joined the rush to Pierce City, where he operated the Benjamin F. Yantis Store. The very next year, the popular storekeeper was again elected to the Washington territorial legislature.

While it lasted, Oro Fino outpaced Pierce City. It had several general merchandise and grocery stores, including Hexter and May, Higby and Bledsoe's, Swanson's, Ankeny and Sons, Sellers and Company and C.C. Hanson's. The Nez Perce Hotel, the Union Hotel and the Hotel El Idaho served the transients. The saloons included Bostwick and Pucketts and Pat Ford's Saloon. The Miners' Restaurant was a popular spot to put grub away.

One of the Oro Fino merchants was Levi Ankeny, who ran Ankeny and Sons with his stepfather, A.P. Ankeny. Levi was born Levi Schmidt in 1844. His family joined a wagon train from St. Joseph, Missouri, for the Willamette Valley, and his father died while the train was crossing the plains. Ankeny eventually adopted Levi, who assumed the Ankeny name. A.P. Ankeny was an early-day river pilot who also owned a pack train and drove cattle to the mines before he got into

# The Gold Rush

merchandising. Ankeny did very well at Oro Fino. He then moved to Lewiston, where he operated a mercantile store with his brother. They sold miners' supplies and grubstaked miners and did very well at that as well. He later moved to Walla Walla, where he was elected to the United States Senate.

Miners were used to working in remote areas, and Oro Fino defined remote. They were a self-reliant bunch, but what they could not do for themselves, they had to rely on the merchants for supplies of all kinds and descriptions. Dr. Stapp described the general stores. They carried almost everything, including miners' supplies like axes, hatchets, shovels, bucksaws, pick heads, hammers, nails, screws, all types of files, pack saddles, packhorses, hay, oats, clothing and bolts of all types of cloth.

The shelves also displayed household wares including blankets, sheets, dinnerwares, coffeepots, hand and laundry soap, kerosene lamps, wicks, candles, coal oil, matches, brooms and clocks. Household furniture of all kinds was on the store floor. Clothing for miners included flannel shirts, wool long johns, gumboots and rubber overcoats for hydraulic mining.

Also adorning the shelves were patent medicines, which were about the only source of relief for the weary, sore

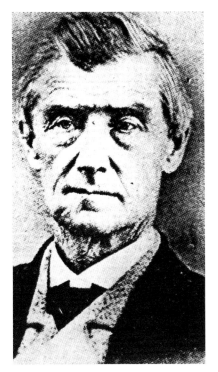

Frank Yantis. *Courtesy of Clearwater Historical Society.*

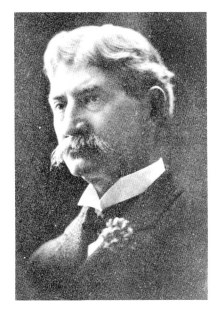

Levi Ankeny. *Courtesy of the United States Senate Historical Office.*

and injured inhabitants of early Pierce City and Oro Fino. If their curative powers were as good as their names were exotic, they were very good indeed. Typical remedies of the day were Hostetter's Stomach Bitters, J. Walker's Vinegar Bitters, Dr. Jayne's Expectorant, Abolition Oil, Centaur Liniment, Russia Salve, Jamaica Jinger, St. Jacobs Oil, camphor and "pain killer," which was probably morphine. The ad for St. Jacob's Oil gives some insight to the merchandizing of the day:

> *Seek you a cure, easy and sure*
> *For aching sprains or hurts or pains*
> *Of every sort, in any part*
> *Be of good cheer, the secret's here:*
> *And if you need what here you read;*
> *Your pains you'll end, your ailments foil;*
> *For you will send for ST. JACOB'S OIL*

Leather boots cost fifteen dollars; gum (rubber) boots were twenty-five dollars; camp kettles cost four dollars; and saws went for five dollars. Since most of the miners cooked their own meals and a lot of the mining was done in creek bottoms or at the end of a sluice box, camp kettles and gumboots were hot items.

And then there was the matter of food. The district was no garden paradise. Most of the supplies had to be freighted in by pack trains or wagons from Walla Walla or Lewiston. William Goulder described a mule train bringing in supplies for Lewiston store owners Grostein and Binnard, who also had a general store in Pierce City later in the 1860s, as having "about a hundred mules, all heavily laden, some of them carrying two twenty-gallon kegs of whiskey, some sacks of flour and kegs of syrup, aggregating in weight nearly four hundred pounds on the back of a single animal."

Mutton and beef sold for twenty cents a pound, tobacco for twenty-five cents, potatoes for thirty cents, bacon for forty cents, sugar and coffee for fifty cents and salt for a dollar a pound. One hundred pounds of flour cost eighty dollars, and whiskey went for five dollars a gallon. Locals like Martin Mauli and Peter Hourcade, who raised cattle at the Lolo Ranch; the John Reed family, who also raised livestock; and Grasshopper Jim and his chickens and the milk and butter at the Milk Ranch also did their part.

The Nez Perce Indian farmers who farmed along the Clearwater River supplied a remarkable amount of hay, grain and fresh vegetables and fruit. Henry and Eliza Spalding had taught them how to farm at their Presbyterian

## The Gold Rush

mission at Lapwai Creek. During the gold rush, those Nez Perce who had taken to farming were raising crops and animals on the South Fork of the Clearwater, at the mouths of Ford's Creek and Oro Fino Creek and a ways up the North Fork from Ahsahka.

Just how much fresh produce they supplied during the peak of the gold rush isn't known, but by 1881, the *Nez Perce News* reported that the farmers at those locations had produced 41,400 bushels of wheat, 7,375 bushels of corn, 24,050 bushels of oats, 200 bushels of rye, 9,500 bushels of potatoes, 3,100 bushels of turnips, 3,150 bushels of onions, 4,500 bushels of carrots, 750 bushels of beets and 14,500 cabbages. They also raised melons, tons of hay and many milk cows, steers, hogs and chickens. They had mastered the art of farming, and the fruits of their labors were welcomed by the miners, merchants and families in Pierce City and Oro Fino.

A fellow named Ed Harris, known to play a mean game of chess, ran a newsstand in Oro Fino that sold books, magazines and newspapers. It was a popular place. The gold rush coincided with the Confederate army firing on Fort Sumter, so the miners were starved for news about how the war was going. Goulder described one Southern miner as a "fierce, red-eyed secessionist of the most bloodthirsty type" and his Northern mining partner as a "most pronounced and outspoken black Republican–Abolitionist and

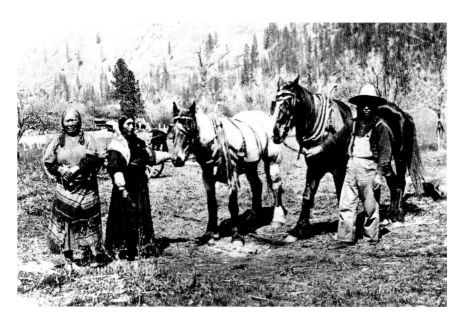

Nez Perce Indian farm. *Courtesy of University of Idaho Library, Special Collections and Archives, Moscow, Idaho.*

uncompromising Union man." So when the news did arrive, there were sharply divided opinions, to the point of knockdown drag-outs.

News was hard to get, and if it had not been for the pony express, there would not have been much at all. Three express delivery businesses had offices in Oro Fino: Wells Fargo, Tracy and Company and Mossman Express. Isaac Mossman, who ran Mossman Express, in his book *A Pony Expressman's Recollections*, described his experiences as an expressman between Walla Walla and Oro Fino. He started his express business with "only one pony and $5 in money and one pair of blankets, but with plenty of grit." He left Walla Walla on April 5, 1861, for Pierce City. He went past Whiskey Creek on to Touchet, where Dayton is now, on to the Tucannon and then on to the Pataha and from there to the Alpowa. He followed the Alpowa down to its mouth and crossed the Snake River at the Silcott Ferry near its confluence with the Clearwater River.

There, Mossman hooked up with a pack train headed for Pierce City. They spent four days shoveling their way through snow that was four to five feet deep. But when he arrived at Pierce City, he received a lot of letters to carry to Walla Walla at fifty cents each. His return to Walla Walla was complicated by the lack of places to stay over and rest. There were a couple of ranches that welcomed him, but for the most part, as he put it, "I had to carry a cold lunch with me which consisted of raw bacon, raw onions and crackers. I slept where night overtook me." He made five dollars on his first trip. He doubled his money the next trip, and after that, one might say, he was on for the ride.

By July, Mossman had acquired ten saddle ponies that he positioned at convenient intervals along the way so he could change horses two or three times a day. They were probably the Cayuse ponies that were bred by the Cayuse tribe

Isaac Mossman. *From* A Pony Expressman's Recollections.

and were known for their versatility and endurance. About the same time, a competitor, Tracy and Company, moved into town. Ned Tracy, Ned James and Ned Norton owned the company, and according to Mossman, "they employed some of the best riders to be had—one was Billy Albright, another was George Reynolds (better known as Cayuse George)—and many a hard race I had with him between Walla Walla and Oro Fino."

One of the races involved carrying newspapers with news about the Civil War. Each rider knew that the first one to arrive at Oro Fino would make the papers carried by the laggard old news. When Mossman arrived at the Greer ferry, Tom Beall told him that Cayuse George and Albright were about a half hour ahead of him. But Beall told him that "they would be sure to stop at the Texas Ranch to gin up." Mossman "skipped around [the ranch] like a skulking coyote into the darkness of night" and then "rode like the devil himself" to Oro Fino, beating his competitors by four hours. "I had made a scoop worthy of a New York newspaper reporter," he bragged and then gloated that Cayuse George and Albright got the "horse laugh."

Sunday was the big commercial and recreation day during the mining season. Having worked long hours for six days out on the claims, on Sunday morning, the miners would troop into town to have their tools repaired by the blacksmiths and buy new tools, clothing, boots, food for the week and other supplies. Miner J.D. Locey described it this way:

> *During the week the towns* [Pierce City and Oro Fino] *are dull, and but little trading is done. But in the coolness of Sabbath morning, from every direction, along narrow mountain paths come in long bearded, flannel shirted miners, until the streets and saloons are crowded from a distance of several miles, to buy provisions or get a battered pick sharpened, or it may be only to borrow a short oblivion from the monotony of camp life and to lay aside even in thought the weary six days burden.*

One of the highlights of every Sunday was in Oro Fino at noon when the express man would gallop into the Wells Fargo station with the week's mail. William Atlee, the express agent, would stand before the assembled crowd and call the roll. William Goulder said of the letters, "They are letters from dear ones in distant homes—letters in which the kisses are yet warm and the heartbeats yet audible." No wonder these rough-and-tumble miners left the gulches and creeks to come to town for the mail.

Imagine the cacophony of sounds: the clang of the blacksmith's hammer pounding the iron on an anvil, the braying of the pack mules, the whinnying

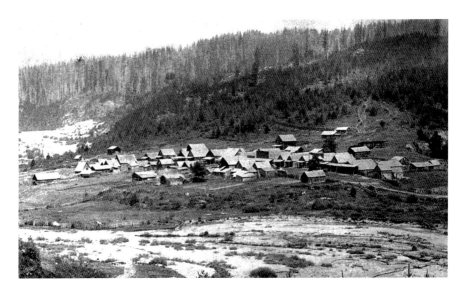

Early Pierce. *Courtesy of Clearwater Historical Society.*

of the saddle horses, the sound of music and laughter wafting out of the saloon doors and the chatter of the miners catching up on the news—news of a new find or of a claim lost in a card game. And then there were the smells: the coal smoke from the forges, the cigar smoke from the saloons, the horse manure, the aromas from the kitchens and the smell of fresh hay from the livery stables. Times were tough; times were good. There were heroes and villains, housewives and whores, miners and merchants, all working out the fates life had dealt them the best they could.

Early-day mining did not lend itself to families. As soon as there was news of a new find, the miners packed their packsacks and were on the trail again in search of the next bonanza. That did not leave much time or room for wives and children. One wonders if the young Patrick Gaffney or Billy Rhodes would have made it to Pierce City if they had had more mouths to feed than their own. Yet, despite the hardships, some families made their way to early-day Pierce City and Oro Fino, and their children had to be educated.

Until there was a school in Pierce, Patrick Gaffney paid miner Edward "Ned" Hammond to teach Frank and John. It was either that or no formal education at all. Hammond was an unusual miner for those times; he was college educated. He was born in New Orleans to an Irish immigrant father and an English immigrant mother in 1830. His father died of cholera when he was four years old, and his mother then moved them to Cincinnati, where he was educated at Xavier

# The Gold Rush

College by the Jesuits. In 1852, he made his way to California, where he mined until he came to Pierce City in 1861. Hammond would go on to distinguish himself as a two-term probate judge and as a territorial legislator for two years.

The first schoolhouse was on Main Street in a building owned by Frank Yantis. Not surprisingly, it had earlier housed a saloon and dance hall. The children who attended the first formal school in Pierce City in 1874 were taught by Eva Yantis, the wife of William Yantis, one of Idaho's earliest formal teachers. The students were Alice Fraser, the daughter of David Fraser; Frank Gaffney and John Gaffney, the sons of Patrick and Bridget Gaffney; and Joseph Molloy and John T. Molloy, the sons of John J. and Ellen Molloy. It was a subscription school, for which the parents, not the general public, paid the costs of the school. Along with the Gaffneys, the parents of these children provide insight to the mettle of the early mining-district families.

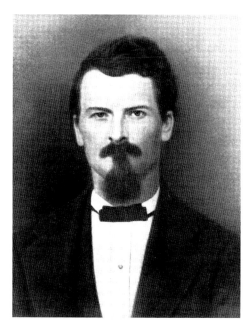

Ned Hammond. *Courtesy of Clearwater Historical Society.*

Unfortunately, little is known about David Fraser's background. His Panamanian wife is never mentioned. He sent his daughter, Alice, to Lewiston for school while he remained alone in Pierce City at his store. He was active in local government and served several years as a county commissioner. Goulder was appointed to the commission to fill a vacancy, and he described Fraser, who was the president of the commission, as a "very prudent, careful and painstaking man in all business matters and relaxed nothing in his watchfulness and care of the business of the county." Goulder said the citizens acknowledged their regard for him when they would say that the commission was "composed of one hundred members, Fraser representing the figure 1, the others being the two ciphers."

John J. Molloy was born in Ireland in 1835 and arrived in the United States as a five-year-old child. As a young man, he labored as a merchant seaman on the sailing ships out of New York City. When the Civil War broke out, he

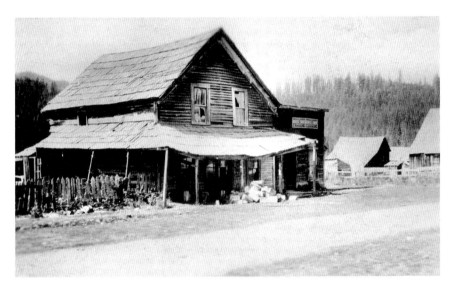

First school in Pierce City. *Courtesy of Marjie Johnson, Viola Molloy Collection.*

served in the Union navy. After the war, he married Irish immigrant Ellen Kelliker in 1865. They moved to Walla Walla, where they ran a restaurant. While there, Ellen gave birth to Joseph and young John. The lure of gold was apparently more attractive than cooking beans and bacon, however, because they moved to Pierce City in early 1869 when young John was a six-month-old infant. While John was working as a freighter and saloonkeeper, Ellen gave birth to Chris (Christopher Columbus) Molloy, Ben (Benjamin Franklin) Molloy and Josephine.

Fate was not kind to the Molloys. Ellen Molloy died in Pierce City on young John's eighth birthday in October 1876. John paid the John Reed family, in what became the town of Fraser, to care for young John and his baby sister, Josephine. Later, John would say that the Reeds worked him hard and fed him little. Chris and Ben were adopted out through the Slickpoo Mission on Mission Creek. Chris was last heard from during the Yukon gold rush, and Ben was killed during a robbery of his adoptive parents' drugstore in Kansas City. Joseph stayed with his father. When young John was sixteen years old, he fled from the Reeds to go to work for Mauli and Hourcade at the Lolo Ranch.

# The Gold Rush

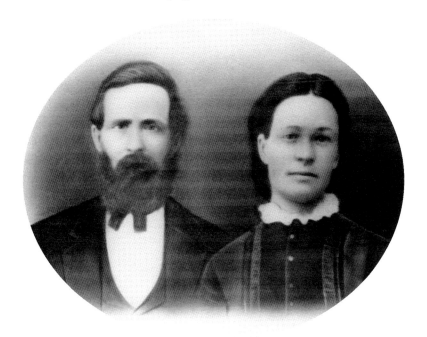

*Above*: John and Ellen Molloy. *Courtesy of Marjie Johnson, Viola Molloy Collection.*

*Right, from left to right*: Joseph Molloy, Frank Gaffney, Israel Cowen and John T. Molloy. *Courtesy of Virginia Gaffney Bird.*

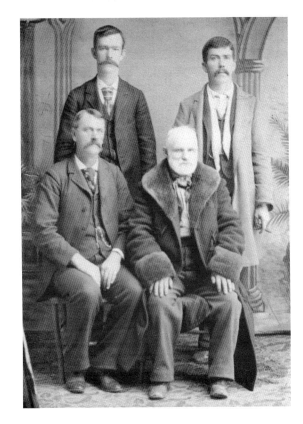

# The Good Times

No matter how hard the miners worked, they were also rowdy men who knew there was more to life than mining. William Goulder knew them well. He said they brought to the district what became a common perspective on the diggings. They had, he observed, "long since shaken off the shackles of an effete civilization, and had been living for many years free from the trammels and restraints of Sunday-school influences. The greenhorns and tenderfeet were not slow in learning how to follow in the footsteps of those who had so long enjoyed that larger liberty that comes from a wild, free life lived so far away in the remote mountain regions." And almost overnight, Pierce City and Oro Fino City became towns where miners could be miners and have a rollicking good time.

According to historian Layne Spencer, all of the saloons and most of the hotels and boardinghouses had liquor licenses that permitted them to sell liquor by the "gulp, quart, gallon or any other quantity." And miners always could find a reason to drink. They could celebrate a lucky strike, drown their woes when they struck out, entertain one of the saloons' dancing ladies, soften up a potential card player, break up the boredom of a long winter or have a drink just for the hell of it. Whiskey enjoyed many monikers, including "tangle leg," "lightning rod" and "tarantula juice." Toasts were common and equally colorful: "here's mud in your eye," "let the hide go with the hair" and "here's to nuggets in your pan." While there were abstainers, historian Beal observed that "everyone conceded that the right to become decently drunk was inalienable." A popular advertisement of the day may explain why the inalienable right was exercised with some frequency:

> *A little whiskey now and then is relished by the best of men.*
> *It smoothes the furrows of dull care and makes ace high look like two pair.*

When it came to whiskey, the saloon owners never seemed to get as much as they had bought, and they couldn't figure out how it was disappearing. Fred Bradbury, who drove a freight wagon as a teenager, later told the *Spokesman Review* how it happened. The barrelheads had government stamps on them about the size of a dollar bill that were glued on and secured with a tack on each corner. The packers would remove some tacks, roll back the stamp and drill a small hole at a tack point large enough for a small straw. Then they would slake their thirst, plug the hole, roll the stamp back into place and then reinsert the tacks. That was not the average barkeep's idea of putting money on the barrelhead!

# The Gold Rush

Despite the "leakage" from the barrels while en route to Pierce City, copious amounts of alcohol were drunk if the sale of the National Bar in 1870 was any indication. Included in the sale were two hundred gallons of whiskey, fifty gallons of gin, twenty-two gallons of rum, twenty gallons of brandy, a case of absinthe, a half case of bitters and one hundred pounds of bar sugar. The sale inventory was also a testament to the other pleasures to be found at a saloon besides a few snorts. There were one thousand segars (cigars), forty dozen decks of playing cards, two cases of Solace Tobacco and two billiard tables together with balls and cues.

And the numerous decks of cards were in the saloons for a reason. It is remarkable that the men who took so many risks to find gold and worked so hard to get it had no problem putting that gold at risk at a card table. Poker, faro, bucking-the-tiger and chuck-luck were the popular card games of the day. There were scheming gamblers in almost every mining camp. But it was also a popular form of entertainment. During the winter, card games would go round the clock. When a player would go broke, someone who was winning at the time would stake him so he could stay in the game. And a gulp of whiskey was never far away.

Goulder recounted a game of five-dollar-limit draw poker that he witnessed at the Greer Hotel. A group of Pierce City miners and Lewiston and Pierce City merchant Herman Loewenberg, who were staying over at the hotel, were playing. A French miner who was known as Pete had also come to the hotel to get out of the snow for a day or two with the hope that he might get a deer on his way back to his cabin. He was minding his own business when Loewenberg, who was a friend of Pete and had become sleepy, asked him to take his place at the table. Pete resisted, but the miners, sensing an easy mark, cajoled him into the game.

Before long, the limit was raised to ten dollars. Players started dropping out, and Pete's luck had turned grim. When he was down to his last few chips, he asked Loewenberg to take his place because he said he was going broke. Loewenberg grabbed his buckskin bag of gold dust, handed it to Pete and said, "Let her all glimmer, but don't bother me anymore." A new hand was dealt; the betting became fierce; the pot became bigger; the players became fewer, and it came down to Pete and one other player. As lady luck would have it, Pete was dealt a very good hand. The other player put up his last chip. At that point, Pete put the bag of gold dust on the pot. Pete laid his cards on the table, and the game was over. We do not know if Pete got his deer, but he went back to Pierce City with a big smile on his face and the poker game's pot of gold in his saddlebag.

There were few women in the early mining camps. Some of them, like Bridget Gaffney and Ellen Molloy, accompanied their husbands. But by and large, female companionship was in short supply. As a result, the dancing girls at the saloons and the dance halls, called hurdy-gurdy halls, were a big draw. The women were generally Mexicans from the Mexico-California border, and they were billed as Spanish dancing girls. The women were not prostitutes. Their trade was dancing, and they were paid a half an ounce of gold for each dance. While not respectable, they were not viewed the same as the women who came to the camps for the purpose of negotiating a price for more than just their affections. Those women made it to the diggings as well.

The earliest record of prostitution was the 1870 census since there was not yet a town in 1860 at which a census could be taken. By that time, the Chinese had replaced most of the white miners and the population was a fraction of what it had been at its peak, so the number of prostitutes who were there during the peak of the gold rush isn't known. But the 1870 census confirms what one would expect in two mining towns whose inhabitants were mostly male. There were several Chinese prostitutes. Jane Baker, who was then twenty-five years old, was the only white woman identified as one. She was from Oregon and apparently did quite well because she bought a house in 1868, which she sold a few months later.

# 2
# A NEW TERRITORY

## THE ROBBERS AND THEIR SHEBANGS

As in life, there were the good times, and there were the bad times. The good times were when the miners went to Pat Ford's Ford Saloon in Oro Fino, which was known throughout the district for its attractive Spanish dancing girls. One of the bad times was in September 1861 when Henry Plummer's gang murdered the popular Pat Ford.

There were two Henry Plummers: the one the people of Lewiston thought they knew and the one the people who were waylaid on their way to the Oro Fino Mining District got to know. In Lewiston, he was a lithe, graceful, well-dressed and handsome man with blue eyes and a neatly trimmed moustache who never failed to charm the ladies. According to historian Howell Birney in his book *Vigilantes*, Plummer was a professional gambler at a time when "the gambler, the saloon keeper and the dance hall proprietor were recognized as readily as the doctor, the lawyer and the merchant." Even the staid and somber *History of North Idaho* acknowledged his "urbanity, polish and personal magnetism."

The Plummer that the miners and packers traveling between Lewiston and Pierce City knew was the one who had been convicted for murdering a man in California with whose wife he was caught and who was wanted for the murder of a man arising out of a fight over a couple of prostitutes in Walla Walla. He was the head of the gang that preyed on them and their gold. Birney says that by the "early summer of 1862 every crooked gambler,

horse-thief, high grader, hold-up man and general tough was a member of the combination owing allegiance to Plummer."

Once Plummer got his gang organized, it operated out of Culdesac. From there, the gangsters established rendezvous points along the way to Pierce City, called "shebangs," where they would "commit the coldest blooded murders with impunity, appropriate to themselves the valuables of travelers, packers, miners returning from a successful summer's work, anybody who might be caught unprotected with gold on his person," according to *History of North Idaho*.

This brazen lawlessness and the lack of any law enforcement to deal with it led to enormous frustration. No one traveling between Pierce City and Lewiston was safe from the risks of murder and mayhem. Ordinary citizens put their very lives on the line if they challenged these criminals individually. The *History of North Idaho* explained that the "few who defied the roughs and openly opposed them were marked for slaughter. The customary method of disposal was to embroil them on a quarrel and under of color of self defense to inflict a death wound with the ever ready pistol or bowie knife."

Vigilance committees were born out of this frustration because, as historian Beal put it, "when a society is primitive, when authority is too weak, too far away, or too corrupt to arrest rampant lawlessness, the duty of law enforcement falls upon those citizens who are willing to curb the criminal." As a result, the vigilance committees became the "law" of the day. They were especially well organized at Lewiston, which was considered by many to be a den of iniquity, and at Mount Idaho, where the miners in Elk City and Florence had become easy prey. To avoid individual retribution, the members kept their identities secret, and they often wore masks.

This test of wills between crime and punishment came to a climax with the murder of Pat Ford. Posing as road agents, the gang confronted Ford and some of his companions while they were riding from Lewiston to Oro Fino. Ford knew some of the gang members and told them he was on to their stunts and was going to keep an eye on them. A quarrel ensued, and the gang followed Ford and his friends into town. Rather than follow Ford into his saloon, the gang shot up the town, forcing people into their houses. Ford went out on the street to confront them with a revolver in each hand. He was no match for the gang; his body was riddled with bullets.

Ford's murder generated so much anger that Birney says it "developed in all of the bandits a lively fear of a rather irritating neck ornament known as a 'California collar' and there was a general and very hasty exodus." The vigilantes at Bannack and Virginia City, in fairly short order,

introduced the renegades' necks to a long drop at the wrong end of a short rope. Historian Birney reported that by February 3, 1864, "twenty-one of the [Plummer] band had been hanged, four banished, and the few that remained alive had left Montana so far behind them that no man in the territory felt a moment's uneasiness."

## Law and Order Come to Town

The Washington Territory created Shoshone County in 1858 and reconfigured it in 1861 to include the burgeoning Oro Fino Mining District. But it was not a functioning government. According to *History of North Idaho*, "there were no county organizations; no local officers of the law; no courts. In fact the county was a veritable haven for escaped convicts, desperadoes, thugs and thieves and abandoned characters of every variety." Also of concern were those who had come from the east and "brought with them all the bitterness and prejudice engendered by that [Civil War] strife and the violent expression of this prejudice was the occasion of many a personal encounter." And when it came to gangs like Henry Plummer's, you were on your own.

While miners' meetings worked well for mining-related disputes, it was not designed or intended to govern a county. The *History of North Idaho* recounts a growing consensus that a "country into which vagabonds, desperadoes and abandoned characters had flocked from all parts of the west was very badly in need of courts, if the peace and dignity of the territory was to be maintained there at all." As a result, an election of county officers was held at Pierce City on July 8, 1861, under the supervision of the Walla Walla County auditor. Three commissioners, William Caldwell, James Griffin and John Tudor; a sheriff, R.L. Gillespie; a probate judge, D.M. Jessee; an assessor, H.M. Bell; a treasurer, L.H. Coon; a coroner, D. Bell; and a constable, F.M. Van Nostron, were elected, and what is now Idaho had its first elected officials and Pierce City became its first county seat.

While there were only three commissioners, there were often four votes. John B. Lauck, an experienced and able man in his seventies from Philadelphia, was the auditor. In that capacity, he was also the ex officio clerk of the board of commissioners. He took his job very seriously, as William Goulder discovered when he was appointed to the commission.

*Not always content with the discharge of his own duties as clerk, he often took a leading part in the discussions of the Board and insisted on having his vote recorded on all questions. When some one of the three members of the Board held a dissenting opinion, "Squire" Lauck, as we called him, would sometimes vote with the dissenting member. This caused a tie vote, which was, to say the least, somewhat embarrassing. On such occasions the president of the Board would beg the clerk to confine himself to his own special duties, reminding him that he was not a member of the Board, but simply its clerk. This would cause quite a fierce little family jar for a moment, but soon all would quiet down, and the good old "Squire" would go on voting as usual.*

The court records reflect just how primitive the local government was. At the May 1862 court term, the county commissioners appointed Charles F. Marvin and S.F. Leonard to select a site for a "permanent courthouse, a building of great need, as heretofore the county had been paying out considerable money in rent." The commissioners then appointed Sheriff R.L. Gillespie to design the building. The committee chose a site, and on June 7, 1862, the commissioners accepted a bid for the building Gillespie had designed from K.C. Reed and W. Keith to "build a courthouse and jail at Pierce City for $3,700 in county script."

Men used broadaxes to hew the logs to the square timbers specified by the commissioners. They then joined the timbers by half dovetailed notches.

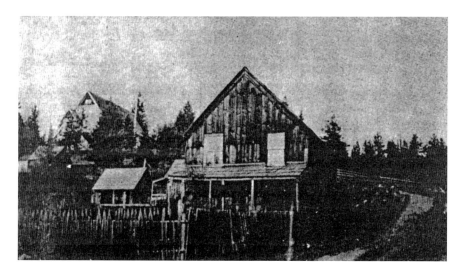

Shoshone County Courthouse at Pierce City. *Courtesy of Clearwater Historical Society.*

# A New Territory

The first floor housed two jail cells and the sheriff's office. The carpenters installed iron bars in the cell windows and drove kegs of nails into the cell walls to prevent prisoners from cutting their way out. An outside staircase at the rear of the building led to the second floor, where the court would convene, the commissioners would meet and the records would be kept. It was completed in August.

Once the courthouse was built, people used it. And it is remarkable the extent to which court records reflect the people and culture of the times. The first document filed at the courthouse on September 1, 1861, was a mechanic's lien for work W.C. Greaves had done on the claim of Lusk and Company. He sought $100 for making and putting in an over shot (water) wheel, $14 for making and putting up water wheel boxes, $160 for furnishing thirty-two sluice boxes at $5 a box and $25 for an indecipherable item.

## The Quest for a New Territory

While the Shoshone County Courthouse was being built, political maneuverings were afoot at the territorial level. Shoshone County was in the Washington Territory, and it was sending legislators to the territorial legislature in Olympia. But a lot had changed in the two years since gold had been discovered. In late 1861, Pierce City and Oro Fino together had almost twice the population of either Olympia or Vancouver. Lewiston was becoming a commercial center. Gold had been discovered on the South Fork of the Clearwater River at the American River and the Red River at Elk City and in the Salmon River country at Florence. Gold strikes at Silver City and Idaho City were opening up the Boise Basin. Idaho and Nez Perce counties were carved out of Shoshone County in December 1861, and Boise County was formed in January 1863, reflecting the population growth at the new diggings. There was a growing sentiment by the independent-minded citizens east of the Cascade Mountains that they would like to chart their own course. The commonality of interests between the mining camps and the Puget Sound was elusive to the miners.

The plot to create a new inland northwest territory was hatched at Oro Fino in the summer of 1862 at what would later be referred to as the Oro Fino Conference. Attending the meeting were William H. Wallace, the Washington Territory congressional delegate; Selucius Garfielde, Washington Territory's former delegate to Congress; Anson Henry, a physician and land surveyor;

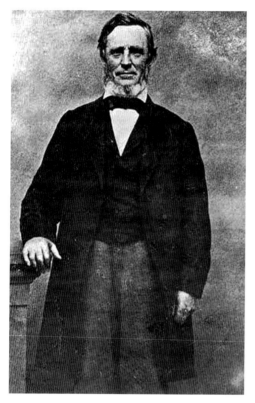

Anson Henry. *Courtesy of Abraham Lincoln Presidential Library and Museum.*

and George "Growler" Walker, a gruff, self-made man and an influential carpenter and wheelwright from Sliver City. There are no written records of the meeting, but the decision was made to initiate legislation creating a new territory east of the Cascades.

The prospects were good because of the plot's backers. Henry had been Lincoln's personal physician in Springfield and had collaborated with him in local Whig politics. During Lincoln's bout with depression during 1841, it was to Henry that Lincoln turned for help. Henry moved to Oregon in 1853 when he was appointed the Indian agent for Oregon. He and Lincoln corresponded during the times they were apart, especially about politics. Once Lincoln became president, he appointed Henry the surveyor general of the Washington Territory. The nature of their close personal friendship was revealed by Lincoln's description of him to a new Oregon congressman:

> *What a great, big-hearted man he is. Henry is one of the best men I have ever known. He sometimes commits an error of judgment, but I never knew him to be guilty of a falsehood or an act beneath a gentleman. He is the soul of truth and honor.*

Wallace was born in Ohio in 1811. He studied law and become a member of the Indiana bar. His brother, David Wallace, served as the Whig governor of Indiana, and his nephew, Lew Wallace, would become the governor of the New Mexico Territory and author the book *Ben-Hur*. Wallace became active in Iowa Territory politics and was elected to the territorial legislature. After

# A New Territory

Governor William Wallace. *Courtesy of Idaho State Historical Society.*

losing a race for United States Senate in Iowa, he moved to the Washington Territory in 1853. Lincoln then appointed him the governor of the Washington Territory, but he was elected as the territory's congressional delegate before he took office as the governor.

Garfielde was born in Vermont in 1822 and, as a young man, made his way to Kentucky, where he was a newspaperman and served as a delegate to the state constitutional convention in 1849. Two years later, he migrated to California, where he studied law and practiced in San Francisco. After a brief interlude back in Kentucky, where he served as a delegate to the Democratic National Convention, he made his way to Washington Territory

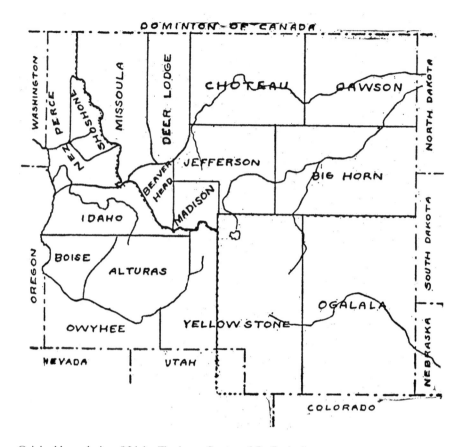

Original boundaries of Idaho Territory. *Courtesy of Dr. Darby Stapp.*

in 1857, where he served as the recoverer of public moneys. Although he lost the race for Washington Territory congressional delegate in 1860, he brought a bipartisan flavor to the plot.

Growler Walker came from the southern part of the territory where the population had shifted. As a native Idahoan who was highly regarded, he brought substantial political heft and evidence of local support to the endeavor. The legislation was introduced, and Congress created the Idaho Territory on March 3, 1863. It was a 326,373-square-mile area that included much of what is now Montana and Wyoming.

William Wallace was the Washington Territorial delegate to Congress when Lincoln appointed him governor of the new Idaho Territory on March 10, 1863. William Daniels of Oregon was appointed territory secretary. For reasons that are not clear, except for his demonstrated preference of

# A New Territory

Washington, D.C., over the Washington Territory, Wallace waited until September 22, 1863, to come to Lewiston to issue his proclamation organizing the territory. He set October 31, 1863, as the date to elect the congressional delegate and the territorial legislators, and he designated Lewiston as the site for the first legislative session. Wallace had no sooner issued his proclamation as governor than he announced his candidacy for congressional delegate.

The political complexion of Idaho Territory at the time was, to put it simply, complex. Missouri had stayed in the Union, but there were many Confederate sympathizers who had come to Idaho to escape conscription and the indignity of having to fight for a side they did not want to win. By the same token, those who had come out from New England and the upper Middle West were abolitionists and fervent Unionists. At the time, however, the Southern Democrats considerably outnumbered the Northern Republicans.

The Mormon population at the Franklin settlement near the Utah border was also growing, and they voted overwhelmingly Democratic based on the discrimination they had suffered in Republican New York, Ohio and Illinois and the anti-Mormon campaigns by the local Republicans of that time. The political insiders assumed the Democrats would prevail based on sheer numbers.

The Republicans held their convention at Mount Idaho and nominated Wallace as their candidate for delegate to Congress. The location of the Democratic convention is disputed. Goulder, who was active in politics and personally attended the Republican convention, said the Democrats convened in Idaho City. Historian James Hawley in *History of Idaho: The Gem of the Mountains* wrote that it was at Packers Cabin, which was a remote cabin in what is now Meadows in Adams County. In either event, they nominated John Cannady, whom Goulder, a staunch Republican, considered a good and decent man

To everyone's surprise, Wallace "won" handily. Election fraud was suspected at Fort Laramie. Historian Hawley, a staunch Democrat, recounted that "about two weeks after the election what purported to be the returns from Fort Laramie came in, showing a majority of over six hundred votes for the Republican candidate…As a matter of fact there were not fifty legal voters in the entire Fort Laramie district." Whether or not it was true, the matter was not pursued; Wallace became the congressional delegate, and the Idaho Territory was without a governor.

When Wallace resigned as governor after his election as congressional delegate, President Lincoln promptly appointed territorial secretary Daniels as the acting governor. Daniels remained in Idaho Territory through the first

territorial legislative session, after which he hastily beat it back to Oregon. That left only the assistant territorial secretary as the acting governor. Lincoln, however, wasted no time. On February 26, 1864, he appointed Caleb Lyon of New York State to be the second territorial governor. Apparently being no more anxious to come to Idaho than Wallace had been to stay there, he waited until midsummer before he deigned to come to Lewiston.

Lyon had served four years as the consul to Shanghai under President James Polk. He then went to California, where he served as the assistant secretary of the California Constitutional Convention. Following that venture, he returned to New York, where he served one term in Congress. When he arrived at Idaho Territory, he got in the middle of the hottest dispute of the time when he facilitated Boise's theft of the capital from Lewiston. Thomas Donaldson, in his book, *Idaho Yesterday*, says that Lyon "came into office in a storm and left it in a

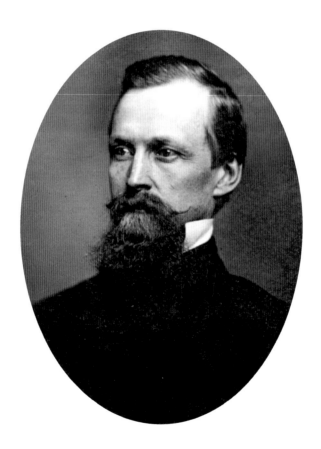

Governor Caleb Lyon. *Courtesy of Idaho State Historical Society.*

cyclone." Idaho pioneer newspaper reporter J.S. Butler described him as a "conceited, peculiar man, who made many enemies and misappropriated much of the public funds." Odd as he was, Idaho Territory finally had a governor.

The Shoshone County voters elected Stanford Capps to the legislative council. It was the upper house, and it had seven members. With the help of Thomas Jefferson's book of rules, Capps served as the council's first parliamentarian. James Orr, a Pierce City miner, was elected to the legislative assembly, which had thirteen members, although only eleven showed up. Little is known about Orr, but Stanford Capps was a prominent and well-liked Pierce City figure. He was a lawyer who owned a general store and a saloon, and he was, by all accounts, a Republican by conviction and a saloonkeeper at heart. His friend and Republican

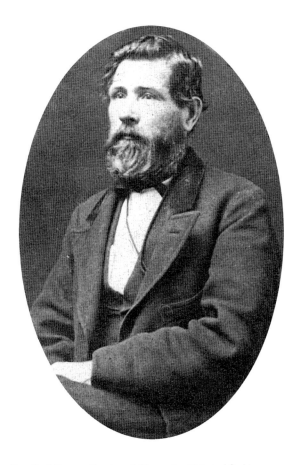

Stanford Capps. *Courtesy of Clearwater Historical Society.*

compatriot William Goulder said that "like all other Republican saloon keepers I have known, he was broad and liberal in his political views and never noisy or demonstrative." He welcomed everyone in, and they were free to give speeches, sing songs and hold meetings. The "crowd could not be too big, too variegated, too jolly or too noisy to suit Capps."

The legislature met in Lewiston on December 7, 1863. It and the two following legislatures were Democratic, or as historian Donaldson put it, they "were frightfully Democratic and Rebel in sympathy, and all United States civil officials were looked upon as aliens and enemies." But there was a lot to do, and acting Republican governor Daniels and the "frightfully Democratic" legislature got down to business. The legislators created new counties, enacted a criminal and a civil code, set up an elections process, created the various territorial departments and agencies and established salaries for territorial officials.

Roads were the pressing issue. Getting people and freight over the long and arduous distances was at best difficult and was an obstacle to economic growth. The legislature granted several franchises for toll roads, bridges and ferries. It also asked Congress to build a military wagon road from the Columbia River to the Missouri River and to establish a mail route between Salt Lake City and Lewiston.

After dealing with all of the mundane issues it faced, the legislature got down to the really serious business at hand—morals. It passed a bill called "An Act for the Better Observance of the Lord's Day." It banned theaters, horse races, cockfights, games of chance and noisy amusements on the Sabbath. We do not know how this legislation was received by the miners, who were "free from the trammels and restraints of Sunday-school influences" in a mining district where the Sabbath was more a day of revelry than rest, but it would be a safe bet, even if made on the Sabbath, that enforcement was less than rigorous. Still, for all of that, it was a productive session. The Territory of Idaho was now in business.

With the advent of territorial status, the first courthouse in Idaho was now housing the Idaho Territory district court for the First Judicial District, and Pierce City remained the county seat of Shoshone County. The courthouse records tell how the residents of Shoshone County put it to work.

In May 1863, R.S. Green alleged in his complaint against a fellow named Frank Surprise that "he [Green] is the lawful owner of a certain white mare, now in possession of Def't who wrongfully detains the same from Pl'ff." The judge noted that the mare was surrendered on the day of trial. Another dispute that was settled on the day of trial was a $42.50 bar bill that

saloon owner A.G. Corbett claimed Hiram Millikin owed him. Not to be outdone, Mary Ann McIntire, who had bought Hiram Millikin's saloon, charged that Corbett "did receive at his own instance and request liquors at Hiram Millikin's Saloon in Pierce City at divers times…amounting to thirty eight and 50/100 dollars." The outcome of that dispute was not recorded. One suspects they may have settled it over a drink.

Horses and whiskey weren't the only fodder for the court system. Gerolemo Geovante and two partners alleged the defendants "did unlawfully and without our consent commence to construct a dam to our damage on our claim on Barclay Gulch." But it got worse. The territory charged that O.I. Edmonds "did steal and feloniously take from the house of J.G. Dodge… gold dust (in a malyum) belonging to the said J.G. Dodge…to the amount of one hundred dollars." Edmonds apparently was not stupid enough to spend the gold at Millikin's saloon. The sheriff's return on the warrant reported that he "could not be found in Shoshone County."

The sheriff did not have much better luck with Fredrick Baker, who had been arrested for stealing a pair of boots. The sheriff noted on the file, "Prisoner Broke Custody and cannot be found in said County." But if the sheriff found persons who had a money judgment against them, the proceedings were, at best, summary. James Riley had been adjudged to owe merchant Christian Swendsen $40.75 for board, merchandise and sundries. Sheriff Elijah K. Davidson described his recovery on the judgment: "The said James Riley was found by me in Nez Perce County on Lapwai Creek. I made a search of his person and found $23.75 on his person—it being all the money I could find on him. He paid me $20.00 in gold coin."

While there were several early judges in Pierce City, Israel Burr Cowen was the man whose presence, by virtue of his character and personality, defined the early judiciary in Shoshone County. Cowen was an eighth-generation American of Scottish descent who was born in Lafayette County, Wisconsin, in 1828. The twenty-year-old Cowen left Galena, Illinois, in 1849 with a wagon train on its way west through Council Bluffs and Salt Lake City, on to Eldorado, California. He mined there for thirteen years and briefly taught school until he heard about the discovery of gold in the Clearwater country.

Cowen took a steamboat to Portland and then a stern-wheeler on to Lewiston, where he arrived in May 1862. Having traversed the country in a wagon train and lived in the rowdy and boisterous mining camps, he was probably prepared for the town that greeted him when he stepped off the stern-

Israel Cowen. *Courtesy of Clearwater Historical Society.*

wheeler at Lewiston. When Lewiston became the capital of Idaho Territory a year later, the compilers of *History of North Idaho* described what must have been quite a town:

> *To this infant town of two years, a town of canvas walls and rude primitive structures, of dens of unbridled vice and iniquity, a town which just before had had to resort to a vigilance committee in order to cow the rough element, to such a town was given the honor of posing as the seat of government of a region more than twice as large as California and seven times the size of the Empire State.*

# A New Territory

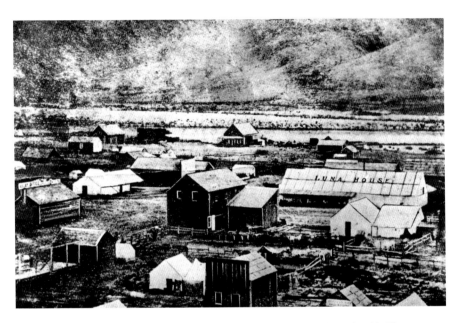

Early Lewiston. *Courtesy of Nez Perce County Historical Society, Bunn/Johnson 75-19-58.*

It is not known if the thirty-three-year-old Cowen dallied in search of fun or soon departed in search of gold, but when he did leave, he traveled the eighty-some-mile trail to Pierce City on foot.

Cowen wore many hats during his long life in Shoshone County, but he was primarily known and respected by everyone in the region as Judge Cowen. He served as the probate judge and justice of the peace for many of the twenty-two years that Pierce City was the county seat. He also served four years as a county commissioner, four years as the sheriff and four years as a territorial legislator. Once the pony express was replaced by a post office, he served as the postmaster of Pierce City for six years. In that capacity, he walked from Pierce City to Lewiston and back every ten days with sixty to seventy pounds of mail on his back. During the winter, he covered much of that distance on snowshoes.

But for all of that, of course, Cowen was still a miner at heart. And mine he did. In addition to everything else he accomplished, he also dug a twelve-mile ditch by hand to bring water to his and others' claims. In addition to all the challenges he faced, he conquered them all with a deformed hand and a clubfoot.

## The Chinese Arrive

At the time the Idaho Territory was created in 1863, other events were transpiring that would forever alter the complexion of the inland Northwest and the character of what would become Idaho. In 1862, President Lincoln signed the Homestead Act into law. In 1863, General Oliver O. Howard of Fort Vancouver forced a new treaty on the Nez Perce tribe. On March 17, 1864, the Montana Territory was carved off the Idaho Territory, and the next year, the miners' committee ended its exclusion of Chinese from the Oro Fino Mining District. Of all these events, the repeal of the Chinese ban in the district and poverty and war in China would converge to have the most immediate impact on the district.

Half a world away, the Taiping Rebellion in the Guangdong area of China between 1850 and 1864 left between twenty and thirty million people dead and millions living in abject poverty. Because they were close to the British enclaves of Canton and Hong Kong, they got news about the West. The "hills of gold" they heard about in the American West proved to be a powerful magnet. By the 1850s, the Chinese were on their way to the California diggings. In the 1860s, the transcontinental railroad construction was underway. Once the Central Pacific Railroad learned that the Chinese would work harder for less money than their American counterparts, the active recruitment of Chinese started in earnest. Chinese labor brokers started recruiting in glowing terms that were hard for a destitute population to resist. One labor broker advertisement said in part:

> *Americans are very rich people. They want the Chinaman to come and make him very welcome. There you will have great pay, large houses, and food and clothing of the finest description. You can write to your friends: or send them money at any time and we will be responsible for the safe delivery. It is a nice country, without mandarins or soldiers. All alike; big man no larger than little man…Money is in great plenty and to spare in America. Such as wish to have wages and labor guaranteed can obtain the surety by application at this office.*

When word got back to China about the work and opportunities that were available in America, the deluge was on. Once an individual Chinese arrived at a location in the States, others from the same town or province would follow and settle in the same place. Often, they were from the same extended family or clan. They received scant comfort and little welcome

from the labor broker or the railroad, whose intentions were to get as much money or work out of them for as little effort or pay as they could. A familiar face and an understandable dialect was the best they could hope for in a strange and hostile land.

Dr. Stapp relates that because there were too few Chinese clan members in the mining camps from a single village or clan to form a cohesive social organization, those who came from the same general region and spoke the same dialect would form district associations known as *hui kuan*. Prominent merchants usually led the associations, and as the number of associations increased, they "banded together and became known as the Chinese Consolidated Benevolent Association, referred to by Euroamericans as the 'Six Companies.'"

At least initially, the San Francisco–based Six Companies exercised control over the railroad laborers and miners. Jack Chen, in his book *Chinese in America*, described the important roles they played for their minions:

> *The family and district associations by 1854 had formed a federation that later evolved into the Six Companies, representing practically all Chinese from those districts or counties from which the vast majority of immigrants came…In its heyday, the Six Companies unofficially spoke for the Chinese of San Francisco and took action to promote the interests of the community and its general welfare, arbitrated disputes among individuals or groups, and organized educational courses for Chinese children. Cemetery associations arranged for burials of deceased immigrants and return of their bones to their native villages.*

As the Chinese population dispersed throughout the West and the workers became more comfortable in their local settings, the fraternization increasingly shifted to the tongs, where the men could go to socialize, which often included prostitutes, gambling and opium.

Unlike other immigrants, most of the Chinese did not intend to stay. Most of them had left families in China, and those were the families they had come to America to support. Once they arrived, they tended to cling to their native customs. They wore their traditional clothes; kept their queues (pigtails), which had religious significance; ate different food with chopsticks; socialized at the tongs; and worshipped at their temples, known locally as joss houses.

The Chinese were unfailingly hard workers who stayed mostly to themselves. But their features, skin color, food, language, clothing and religion were different. They had replaced American railroad construction workers

because they worked harder for less pay. They were slurred as "Chinks" and "Mongolians" and "Celestials." Miners' committees routinely excluded them from diggings. The newspapers of the day warned of the "yellow peril," which took the term "yellow journalism" to a new low. During the 1870s, there was even a "Chinese Must Go" movement in California.

The governments were no better. The Idaho Territory and the Montana Territory imposed a four-dollar and later a five-dollar monthly head tax on them for just being within their boundaries. In 1882, Congress passed the Chinese Exclusion Act that prohibited any further immigration and denied naturalization rights to Chinese already in the country, no matter how long they had been here or how Americanized they had become. The act also denied their American-born children citizenship.

At the same time the Chinese were looking for gold to send to their families, the discoveries at Elk City and Florence in 1861 and at Idaho City and Silver City in 1862 attracted many of the Oro Fino district miners to those diggings. Their philosophy of get what can be got and get out was in play. That left many valuable claims that were not being mined in the Oro Fino district. Since these claims tended to be the ones where the easy gold had already been high graded, allowing the Chinese into the district gave the owners an opportunity to sell or lease their claims before they went on to the next diggings.

The exodus from the Oro Fino district diggings by the original miners and the influx of the Chinese and the general decline of the population were dramatic. By 1865, the district had 120 white miners and 550 Chinese, compared to the more than 7,000 inhabitants who had been there in 1861. By 1870, 6 out of 10 miners in all of Idaho Territory and 8 out of 10 inhabitants in Pierce City were Chinese. The culture of the district changed accordingly. Almost overnight, Pierce City became a Chinese mining town.

As the white miners deserted Pierce City and Oro Fino, the Chinese became the dominant influence in Pierce City for the next twenty-five years. If it had not been for the Chinese, Pierce City would probably have gone the way of other Idaho ghost towns. The extent to which the white miners and merchants had abandoned the Oro Fino Mining District to the Chinese was reflected by the number of votes cast in 1862, when the district cast the most votes in the entire Washington Territory, and by 1885, there were only seven votes cast in Pierce City.

The Chinese did not bring only their work ethic; they also brought their business skills and their traditions of worship, work and recreation. They were undaunted by the cultural and legal hurdles. They flocked to the Oro Fino diggings even before the miners' committee removed the ban. They

# A New Territory

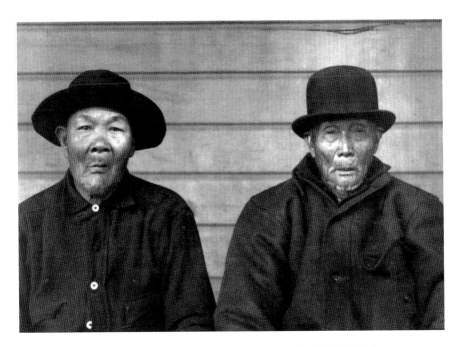

The last two Chinese miners in Pierce City. *Courtesy of Idaho State Historical Society.*

moved the big rocks for the pay dirt under them. They dug miles and miles of ditches through heavily forested land to get water to more distant claims. They rewashed the tailings to get the gold the original miners had missed or not worked hard enough to find. They dug past the pay dirt into the much more difficult bedrock.

Newspaper reporter Allison French described the Chinese men's skill as miners in her *Spokesman-Review* article "Pierce City Mines":

> *Much as we share in the popular hostility toward the Chinese, we cannot but admire the industry and skill of these Pierce City miners, their cleanly habits and their faithful allegiance to the teachings of their youth. Working over the tailings abandoned by the white miners as worthless, the Chinese miners toil away early and late, and in a few years they return to their native land with a snug sum—independence for their old age. And yet they spend their money with apparently as liberal a hand as the white miners. It must be said that they are better skilled than the whites in abstracting the precious stuff from the sands. At any rate they thrive where a white man will starve, and whatsoever their secret is they guard it closely.*

## The Chinese Community

The Chinese were consummate businessmen. They grew and sold vegetables; they operated restaurants and saloons; they ran laundries and general merchandise stores; and they were known to operate a gambling den or two.

Harry Warren, whose parents ran the City Hotel in Pierce City and who grew up there during the Chinese era, spoke about the Pierce City Chinese to the Luna House Historical Society in Lewiston. He said the Duck-Lee-Yung Company store "carried such items as candied ginger root, candied coconut slices, Lichee nuts, opium, tea, and some staple food items, including, of course, rice." Duck and Lee were partners who had started out as placer miners in Pierce City. They also ran a saloon in conjunction with the store. The *Spokesman-Review* reported that it was "An Orderly Place." It said:

> *The saloon is operated in the most orderly manner, and the foreign owners are troubled no more by "bums" than if the proprietors were citizens of the United States. In treating, they equal, if not surpass, the white men, and when a man needs a drink after a debauch and has not the money for its purchase the Chinamen give him the drink. When business is especially rushing a white man is hired as bartender, but at other times a yellow bartender serves the drinks. On a special occasion like the Fourth of July they celebrate by indulging freely in American Whiskey.*

While the Chinese merchants ran traditionally western saloons, they did not abandon their own traditions. The news article noted that at the time it was written, April 10, 1904, "Ah Lee is at present in China visiting the tombs of his ancestors."

Vegetables were a big part of the Chinese diet. In many of the Idaho mining camps, they had big gardens and sold their fresh produce locally. According to Fern Coble Trull, in her master's thesis, "The History of the Chinese in Idaho from 1864 to 1910," Pierce City was no exception. Rice was also a staple, and the Chinese preferred pork to beef. The influx of Chinese drove up the demand for pork to such an extent that, according to the *Idaho Tri-Weekly Statesman*, "some of the Celestials are engaged in butchering, driving hogs from the Walla Walla Valley and selling meat to the rest."

As early as the 1860s, the Chinese were operating a laundry in Pierce City. Trull described how they did it:

# A New Territory

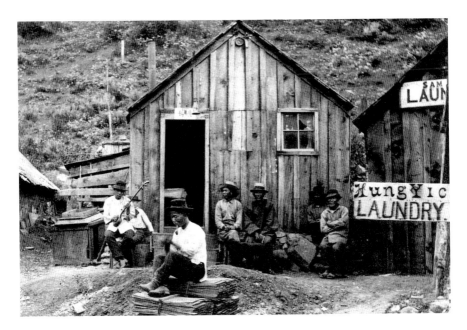

Chinese laundry at Silver City. *Courtesy of Idaho State Historical Society.*

*A shack would be found somewhere in the town, preferably near a creek where the water was plentiful. The Chinese would buy his tubs, a washboard, some soap and a flat iron and he was ready to set up his establishment. In Chinese and English his sign would be displayed and business would come flocking, especially from the white men far from family care. It did not cost much to set up business in those early days. It is said that no white person could compete with the Chinese for snowiness of wash.*

The temple was where weary Chinese could go for a welcome respite from the mind-numbing, back-breaking labor of coaxing a little gold from a lot of dirt. Virginia Gaffney Bird, in her book *Patrick and Bridget Gaffney and Their Descendants*, described the first temple or joss house in Pierce City, known in English as the Temple of All Saints. It was a two-story log building. Most of the first floor was a gambling hall, and there was a living quarter in the rear. The second floor housed the temple. It was an almost poetic pairing of endeavors. Joss houses had ornate altars with gilded characters representing the five Chinese gods: god of the north, god of healing, god of wealth, goddess of mercy and god of justice. It was a safe harbor in an often stormy sea. While there, the people needing help could light a joss stick so the incense smoke could lift their petitions to the most sympathetic god.

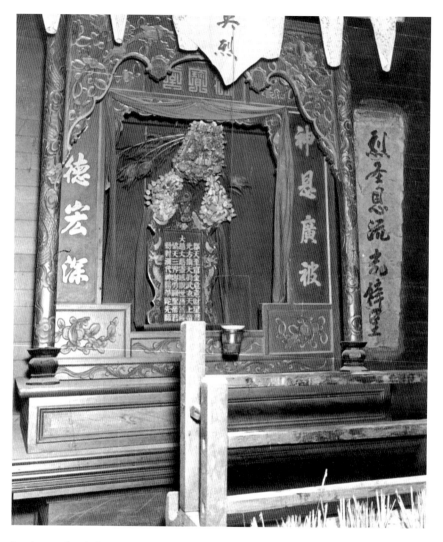

Joss house altar in Lewiston. *Courtesy of Nez Perce County Historical Society 13-8-5.*

As was the case generally, in Pierce City the social centers were the tongs, or Chinese Masonic Lodges, as they were sometimes known. The tong provided social halls, gambling parlors and brothels where the Chinese could visit, drink, gamble, smoke, have sex, make friends, catch up on the news and otherwise socialize with friends. It was also a benevolent society where one could get help writing a letter, arrange to send money back home, get financial aid and resolve disputes. They were often tightly organized and would fight for their territorial turf. But at the end of the day, it was home

away from home in a strange land where hostility was common and violence was indulged.

A penchant for gambling was one trait the Chinese miners shared with their white counterparts. The gambling houses and the saloons were major attractions in a mining town with little else to offer for recreation. Imported from China, Fan Tan, Pai Kow and Pak Kop Piu were the popular Chinese gambling games in Pierce City. Fan Tan was a counting game that was played at a table. The dealer would grab a handful of beans or coins, put them on the table and then cover them with a bowl. The players would then place their bets on the table and guess how many beans or coins would be left after

Gambling card. *Courtesy of Idaho State Historical Society.*

they were divided by four. The person who guessed the right number would get four times the amount he had bet. If no one guessed the right number, the house got the bets.

Less popular was Pai Kow, which was a Chinese version of dominoes. There were thirty-two wooden square pieces with Chinese characters on them. The player who got the most matched pairs won. The third game, Pak Kop Piu, was a lottery. Each ticket had eighty Chinese characters and was known as a "white pigeon ticket" because pigeons were used in China to deliver tickets and winnings to get around the government ban on lotteries. A player would pick ten or more characters and pay a sum for each pick. Each evening, the gambling house would pick twenty characters at random, and the players who picked five or more correct numbers would win money. In the 1930s, Reno, Nevada, which had its share of Chinese miners in the early days, adopted the game and renamed it keno.

Opium was another source of relief from the drudgery of mining. It was commonly accepted and openly used. Harry Warren described its use in Pierce City:

> *They* [the pipes] *were long bamboo affairs with a screwed-in head for loading…First a small amount of ordinary granulate tobacco was placed in the bowl of the pipe. When this was well ignited the smoker would reach into the "tael" or opium can with a stick somewhat resembling a rounded tooth-pick and roll it round and around until an amount of black tarrish opium the size of a small pea adhered to the stick. This was placed on the glowing tobacco and the smoker puffed away quite lustily for a matter of minutes and then gradually went to sleep. Sleep must have been pleasant since the owner often smiled and seemed quite happy. I never saw what might be considered an addict. All were hard working people in a strange land and little time was wasted in pleasure.*

Chinese prostitutes also plied their trade and offered a welcome diversion from the mostly male companionship of those days. By 1870, Lee Dy, a forty-year-old male, was running the local brothel. Because Lee was a man, the brothel was probably run by the local tong. The 1870 census listed eight Chinese prostitutes by name and reported that they ranged in age from twenty to thirty-three years old. Whether the white males were permitted or encouraged to patronize the brothel is not known.

According to Warren, the Chinese also honored their dead every year. They roasted a whole pig for several days and then put it on a litter. Four

Opium pipe. *Courtesy of Dr. Darby Stapp.*

men would then carry the pig at the head of a parade, accompanied by a band with cymbals, drums and a gong. They would then proceed to the Chinese cemetery with the entire Chinese population in single file behind them. The parade walked south down Main Street and then turned right and went until it reached the cemetery on the west side of Oro Fino Creek.

Once the parade reached the cemetery, the Taoist or Confucian priest started a chant, joss sticks were lit and the pig was carried around every grave and then placed in the center of the cemetery. The individual graves were then decorated with a bowl of rice, candied fruit and two red candles. Then there was a concluding ritual, and the ceremony was over. Local lore has it that a white man asked a Chinese when the spirits would come back to the graves and eat the food. The Chinese replied that it would happen at the same time his relatives' spirits came back to smell the flowers.

The Chinese Lunar New Year was the big celebration in Pierce City, enjoyed as much by the whites as by the Chinese. A Chinese elder would give a signal and then he, and others in succession, would rap on the door of the home or business of another Chinese, the door would be opened and each man would grab and shake his own hand. The guest would then be invited in and offered rice wine and treats. The guest would then proceed to the next Chinese home, and the ritual would be repeated. Warren reported that by the time the person had "made the rounds he was a very happy individual." He also added that the whites were "the worse for wear by the time they had had a few rice whiskeys" and that the children were treated to "dried shrimp, Lichee nuts and rare Chinese Candy." The entire celebration was enlivened with lots of firecrackers.

While many Chinese stayed in America, the vast majority returned to China to rejoin their families and to be buried there. Those who died before they could return usually had an insurance contract with their tong to arrange for their bodies to be returned at the appropriate time. Burial in China was a cultural and religious imperative. They believed that the entire family's good fortune depended on the ability of the eldest son to perform a ritual over the body and grave of the deceased father. That belief was their reality, and they took the return of the bodies to China for that ritual very seriously.

As a teenage boy in Pierce City, Harry Warren witnessed the process by which the bodies were prepared for their return.

> *To take care of this* [belief] *their remains were often disinterred, the flesh scraped from the bones, the bones placed in special metal caskets, shipped to San Francisco, and thence to China. I recall outside Chinese coming in and doing the job. One time a bunch of we boys hid near the cemetery and watched until our stomachs rebelled. Just prior to sealing the caskets, the bones were well smoked.*

But even among a group of people who were so discriminated against, they were not above inflicting prejudice against their own. Warren told about an elderly Chinese blacksmith who was shunned by other Chinese and was given only the most menial work by them, such as sharpening bits. When he died, no tong stepped forward to bury him. When pressured by the whites, they resisted because "he was of a different 'tong' and it was not their place to bury him." Only after several days had elapsed and the body had started to decompose did the whites force the issue and the Pierce City Chinese community buried the old man.

## The Plight of the Chinese

Even though the Chinese ban had not yet been repealed, they substantially outnumbered the whites in the mining district during the winter of 1863–64. As the size of the Chinese majority increased, they became less submissive and unwilling to tolerate abuse. By the same token, as the number of whites diminished, they became even more anxious to establish their dominance. As William Goulder put it, the "Celestials" were becoming increasingly "surly and insolent." They were openly shooting their pistols at targets, and others

"would bring out their long knives, take possession of any grindstones that happened to be near, and begin to sharpen up and polish these long, ugly, dagger-like blades." The ill will on both sides was brought to a climax when a Chinese bored a hole in a piece of firewood, stuffed some gunpowder in it and put it in a pile of wood where many of the miners gathered. The piece of wood exploded and the stove was damaged, but no one was hurt.

The suspect was arrested, and a trial was held. During the trial, "volley after volley of revolvers could be heard, while long knives flashed in the sunlight as their owners marched back and forth in front of the Temple of Justice." Inside the courtroom, a "burly miner was waving a long rope around in the air while waiting for a verdict." When the guilty verdict was announced, the judge sentenced the man to be hanged from the neck until he was dead, and he was then taken to a tree that grew at the end of the main street for the purpose of carrying out the sentence. At the hanging tree, several men in the crowd started to plead for the man's life, arguing that the sentence should be commuted to one hundred lashes on the prisoner's bare back. When that was agreed to, they realized that that punishment would also result in death. They finally agreed that eight men would inflict three lashes apiece and the man would be banished from the district. The punishment was administered to the man's bare back, and he was chased out of town in the middle of a very bad winter.

Harry Warren said that "theirs [the Chinese] was the hardest lot of anyone in the camp. Shunted to the poorest claims, robbed, beaten, and degraded in almost every conceivable fashion, yet they managed to survive." Warren continued, "They seldom, if ever, were accorded the right of original discovery of claims. Theirs were supposedly worked out abandoned claims or those of low grade production." And if they had a lucky find, they often would be chased off the claim with no consequences, even though a claim-jumper could be shot for jumping a white man's claim.

The plight of the Chinese miners was made worse when territorial district judge Willis Sweet ruled in 1889 that the Chinese miners could not own mining claims even though the miners' laws had been amended to allow it. Sweet was born in Vermont in 1856, studied printing in Nebraska and moved to Moscow in 1881. A Republican, he was closely associated with Fred Dubois during the anti-Mormon movement. He studied law at Moscow, was the first president of the Board of Regents of the University of Idaho and was appointed district judge and then to the territorial Supreme Court just a few months before he was elected to Congress upon Idaho's admission to statehood. His decision was viewed as a license to jump the claims the

Chinese had bought from the white miners in good faith. That situation was made even worse when Congress passed the Geary Act in 1892, which extended the Chinese Exclusion Act of 1882 for another ten years. The *Caldwell Tribune* reported on June 3, 1893, about some of the consequences:

> *Report has reached Kendrick that there is fighting going on in the Pierce City mining camp. The rioters are the Chinese, who have been working deserted claims, and white men who are now jumping the Chinese workings. The trouble has been brewing for some time. The decision of the Supreme Court on the Geary Law gives the white miners an excuse to attack the Chinese and secure their diggings. Parties from that point report a large sized riot.*

Another recurring reminder to the Chinese of their lowly status was the head tax that Idaho Territory imposed on them. The sole basis of the tax was race. Joseph Boyd recounted his experience with the tax. Israel Cowen was the Shoshone County sheriff during 1868–69, and he appointed Boyd the deputy to collect the tax. Boyd estimated there were eight or nine hundred Chinese in the diggings at that time. As the collector, he received 20 percent of every tax he collected, which by this time had been raised from $4 to $5 per person a month. When he would go to a claim, the Chinese would run into the woods and hide, and his job was to round them up and extract the tax. If they pleaded poverty, he would march them "in pigtail file down the trail to the store where they would borrow the required sum from the store keeper." He made $700 or $800 a month from those working the poorest claims. He commented that "money was easily made, quickly spent and lightly valued in those days in the mining camps." Unless, of course, you were Chinese and had only a "Chinaman's chance."

## A New Nez Perce Treaty

As the miners left the mining district, others stayed for what they viewed as an even more promising prospect—free land. During the gold rush fever, only a few hardy souls had ranched on the prairie, but once the easy gold pickings had been taken, the free land looked better and better to the people who did not share the miners' wanderlust. The Homestead Act permitted a person to stake out 160 acres, pay a filing fee of ten to fifteen dollars, remain on the land for five years and raise crops on it. At the end of those five years,

upon proof of compliance, which was called "proving up," the government would grant a title for the land to the homesteader.

But there was a problem: the Nez Perce thought the land had been reserved for them. The Nez Perce treaty had been negotiated by Washington Territory governor Isaac Stevens in 1855 and ratified by Congress in 1859. It granted the Nez Perce a five-thousand-square-mile reservation that included much of eastern Oregon, including the Wallowa and Imnaha Valleys, all of north central Idaho and some of western Montana. The treaty provided that there would not be any white settlements within the area reserved for the tribe. The Nez Perce had resisted the miners' entry into the Clearwater. But because Oro Fino Creek did not carry a high value for them and the North Fork–Ahsahka and Kamiah bands had established commercial relationships with the mining district, they did not physically intervene.

However, Oro Fino Creek, which provided neither camas nor salmon, was one thing, and the confluence of the Snake and Clearwater Rivers that provided salmon and game and a winter campsite was another. The ranchers who had staked out land between Greer and Pierce City were squatting on or near their camas meadows. Settlers were also eyeing the rich Wallowa Valley and were pressuring the government for access. The Nez Perce complained bitterly that the treaty was not being enforced. The rhetoric grew ugly. Cecil Dryden, in her book *The Clearwater of Idaho*, recounts how the *Golden Age*, Idaho's first newspaper at Lewiston, as early as 1860, "boldly urged the whites to take the land they wanted, plow it up, crop it—and let the Indians object if they dared."

Anticipating problems with the miners and merchants who had moved onto the reservation, the Nez Perce Indian Agency established an office at the old Spaulding Mission site at the mouth of Lapwai Creek in 1860, and the United States Army established Fort Lapwai in 1863 about eleven miles up Lapwai Creek from the agency. Rather than enforce the existing treaty, the government decided to reduce the size of the reservation by almost 90 percent to six hundred square miles. That decision did not take into account that the Nez Perce were loosely organized and were not governed by a single chief. Rather, they were a confederation of bands that had their own territories and chiefs.

Stevens had unilaterally and without the consent of the chiefs of the other bands appointed Chief Lawyer as the nominal head of the tribe during the 1855 treaty negotiations. Lawyer was from the Kamiah band but had joined the Spaulding Mission at Lapwai, where he became a devout Christian and befriended the Spaldings. Aware of Lawyer's friendship with the whites,

Chief Lawyer. *Courtesy of Washington State Historical Society.*

Howard made the appointment despite the fact that the Nez Perce tribe was a loose confederation of bands that didn't have a single governing chief. Joseph was the chief of the band that occupied the Grand Ronde and the Wallowa and Imnaha Valleys. Chief Whitebird led the band on the Salmon River at Whitebird Canyon, and Chief Looking Glass headed the band at Clear Creek above what is now Kamiah. Too-hool-hool-zote was the chief of the band that inhabited the rugged region between the

Snake and Salmon Rivers. Timothy was the chief of the Alpowa band. The Palouse band was located down the Snake River from Lewiston and had three chiefs—Hahtalekin, Hush-hush-cute and Yellow Wolf.

Competing religions also divided the Nez Perce. Henry and Eliza Spalding had located their mission and school at Lapwai in 1836 and had converted some of the Nez Perce to their faith. Joseph Cataldo came to the Pacific Northwest in 1865 from Belgium, where he had been ordained a priest in the Society of Jesus (the Jesuits). He was born in the Kingdom of the Two Sicilies and joined the Jesuit order at the age of fifteen in Palermo. He started his missionary work with the Spokane tribe but was soon sent to minister with the Nez Perce. There, Cataldo was met with a very hostile Indian agent, John Montieth, who thought the reservation should be the sole province of the Presbyterians and tried to exclude him from the reservation. The animosity was aggravated when Montieth was overruled by Washington, D.C., and Cataldo built St. Joseph's Slickpoo Mission at Sweetwater Creek.

Competing with the Christians were the Nez Perce non-Christians, whom the Christians referred to as the Dreamers. Dr. Stapp described the religion as "shaman-centered…with an emphasis on the individual quest for a [guardian] spirit, annual observance of first fruits and first salmon ceremonies, and a winter [guardian] spirit dance." Many of them followed the prophesy of a Shahaptin tribal member named Smohalla, who was thought to have died and resurrected when he returned to the tribe after being wounded in battle and having disappeared from the tribe for a period of time.

The Dreamers opposed any white intrusions into their traditional grounds, including farms, mines and towns. They believed, as Dryden put it, that "Mother Earth was not to be torn by the plow; the great creator had made it as a complete whole—never to be scarred or carved into pieces." Nor did they want Christian missionaries to tell them what to believe. They disdained a god that killed for vengeance and condemned people to burn in a fire forever. They preferred their kind and tolerant Mother Earth who nurtured her people by giving everything she had, including her deer in her forests, her buffalo on her plains, her geese and grouse in her skies and her salmon and eels in her rivers.

The council to renegotiate the 1855 treaty, which was called the Lapwai Council, convened at Lapwai in 1863. Father Cataldo opened the council with a prayer in the Nez Perce language, and it was all downhill after that. The chiefs were skeptical. The presence of Lewiston on reservation land, contrary to the 1855 treaty, proved the government would not keep its word,

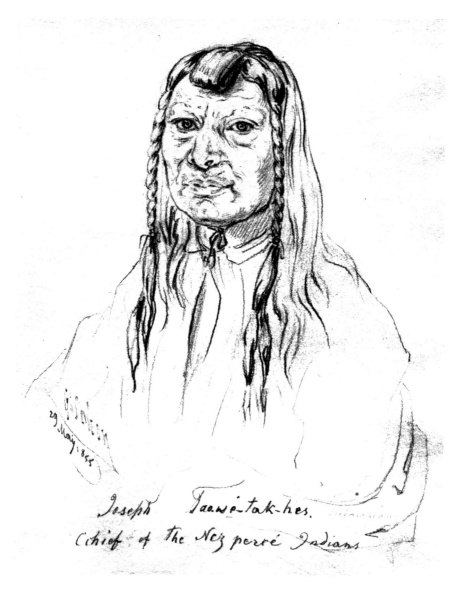

Old Chief Joseph. *Courtesy of Washington State Historical Society.*

and the proposed treaty did not include the Wallowas and the Salmon River, where one of the largest Nez Perce bands had lived beyond their memory.

Old Chief Joseph's response to the promise of compensation was that the land was not for sale. Big Thunder, the chief of the Lapwai band, opposed any treaty because the one they had was never enforced. He and Old Joseph

# A New Territory

viewed Chief Lawyer as a bootlicker. The chiefs who signed were more sympathetic with Lawyer because they did not think he had any choice.

The council concluded when Chief Lawyer and all the chiefs whose bands lived within the new reservation boundaries except Big Thunder signed the treaty. In turn, all the chiefs of bands that lived outside the new boundaries except Chief Timothy of the Alpowa band refused to sign the treaty. The result was that a majority of the chiefs, who represented only about a third of the tribal members, agreed to a treaty that reduced their land by almost 90 percent. The government took the position that all the bands were bound by the new treaty because Chief Lawyer and a majority of the chiefs had signed it. Old Joseph was so angry and disillusioned that he scornfully tore

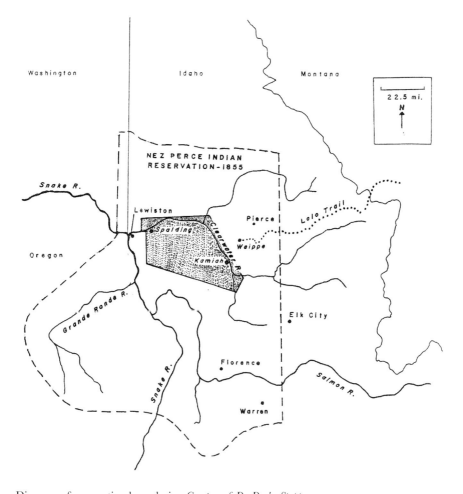

Diagram of reservation boundaries. *Courtesy of Dr. Darby Stapp.*

up his copy of the treaty, destroyed his Bible and turned his back on the whites to the day he died in 1871.

After the reservation was reduced in size, Lewiston was no longer within its boundaries. People could now homestead there and buy and sell land. But the Weippe Prairie and the land between there and Greer were still within the reservation. As to that area, the treaty provided that the portion of the reservation "lying north of the Snake and Clear Water rivers and the South Fork of the Clear Water and the trail from said South Fork, by Weippe Root ground across the Bitter Root mountains, is hereby opened to the whites, but shall remain for the exclusive use and benefit of the Indians." Since the Homestead Act did not apply to reservations, the ranchers who had settled between Greer and Pierce were still squatters.

## Clouds of War

During the 1860s and 1870s, just a few settlers staked out claims on the prairie land between Greer and the Pierce divide. The Texas Ranch, which played such a key role during the gold rush, is acknowledged to be the first ranch, not only at Fraser, but in the entire area. It was quite an operation for the times. By 1870, it had 19 horses, 230 head of cattle, 20 hogs and 10 chickens included in the census report of that year. Young John Molloy, who worked there as a youth, said the "place had a reputation for its hospitality. No one ever came there but was well fed as long as he cared to stay, and lunch enough to take him to his next destination."

The Poujade Ranch, which played an even more critical role during the gold rush, was at Ford's Creek. After gold was discovered at Idaho City, the Poujades left for the Boise Basin and later settled at Silver City, Nevada. The next few arrivals generally settled between the Poujade and Texas Ranches. The John Alsop family arrived in 1872 at what was called the Hole-in-the-Ground Ranch. Next came the John D. Reed family, who settled south of the Fraser post office on the breaks of the Lolo. Known as the Cattle Ranch, it was a major supplier of beef to the merchants and miners in Pierce City and Oro Fino.

Another early settler was Patrick Keane. Keane was born in Ireland in 1844, came to the United States in 1867 and went on to Pierce City the next year. He soon decided he would rather be a farmer and raise crops than be a miner and raise hell. He married Mary Greer, who was the daughter of Irish

# A New Territory

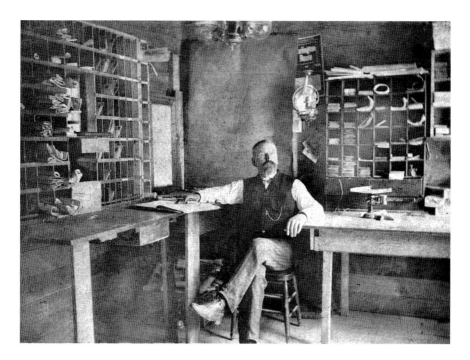

Patrick Keane. *Courtesy of Clearwater Historical Society.*

immigrants James and Mary Greer, not to be confused with John Greer, for whom the town of Greer is named. Keane's ranch was located a mile west of the Texas Ranch, and he farmed it for sixteen years. He also served six years as the Fraser postmaster and then served in the same capacity for several years in Greer.

In 1875, Wellington Landon decided to settle on the Weippe Prairie. Landon, known as the "Duke," was born in New York State in 1830. His grandfather had fought as a general during the Revolutionary War and was killed in a battle on the St. Lawrence River. When his parents died during his fifteenth year, he ventured out on his own and got into the lightning rod business and then took up locomotive engineering. That took him to gold mines in Colorado, where he had a butcher shop. He then mined in Montana Territory, Elk City and at Pierce City before he staked out his land claim on the prairie, where he started raising cattle and hogs. And, as the *History of North Idaho* quaintly put it, "He has always been independent in political matters and has never seen fit to launch a craft on the sea of matrimony." Thus began what would become the town of Weippe. He would later donate the forty acres that would become the town site.

In the meantime, Pierce City had become a Chinese town with fewer than one hundred whites. The mining had moved south to the Salmon River and the Boise Basin. Virginia City and Silver City were also beckoning the itinerant miners. The farmland was becoming ever more attractive to families who wanted to settle down. The rich farmland in the Wallowa Valley was especially appealing to settlers. But once again there was a problem—the Nez Perce were still occupying the Grand Ronde Valley, including the Wallowas.

Old Chief Joseph had died in 1871. His last words to his son Young Joseph, who would become the new chief, were:

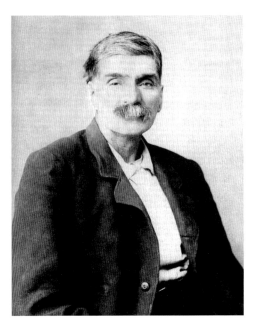

Wellington Landon. *Courtesy of Weippe Hilltop Heritage Museum.*

> *My son, my body is returning to my mother earth, and my spirit is going very soon to see the Great Spirit Chief. When I am gone, think of your country. You are the chief of these people. They look to you to guide them. Always remember that your father never sold his country. You must stop your ears whenever you are asked to sign a treaty selling your home. A few more years and the white men will be all around you. They have their eyes on this land. My son, never forget my dying words. This country holds your father's body. Never sell the bones of your father and mother.*

True to his word, Young Joseph's band and the other nontreaty bands stayed in their ancestral lands after the 1863 treaty was signed. And although his father was not a signatory to the treaty and was angry that it had been signed, there was an implicit understanding between the government and the chiefs who did sign the treaty that Joseph's band could remain in the Wallowas.

Notwithstanding the understanding, pressure to make the Wallowas available for settlers increased. In 1873, Oregon governor L.F. Grover urged interior secretary Columbus Delano to forcibly move Joseph's band to the reservation

at Lapwai. That same year, the Interior Department tried to remove those whites who had already settled in the Wallowas, and it was met with such fierce opposition that it withdrew its efforts.

Things came to a head in 1876 when a dispute arose between some Nez Perce and two whites who were looking for some lost horses that they suspected the Indians of stealing. They happened upon a Nez Perce camp and proceeded to search for their horses at the camp. An altercation broke out that resulted in one of the Nez Perce being shot and killed. The two men were acquitted at a trial, but Joseph demanded that they be tried by Indian law. When the demand was ignored, Joseph ordered the whites out of the Wallowa Valley.

Young Chief Joseph. *Courtesy of Smithsonian Institution.*

Troops from Fort Walla Walla were sent to the Wallowas to maintain peace. General Oliver Otis Howard was appointed to head a five-man commission to investigate the situation and make recommendations. Howard was born in 1830 in the state of Maine. He was commissioned from West Point in 1854 but considered leaving the army for the ministry after a religious epiphany in 1860. The Civil War interrupted his plans, and he fought courageously during many of the battles, one of which cost him an arm. Following the war, President Andrew Johnson appointed him the chief commissioner of the Freedmen's Bureau, which was established to improve the plight of the freed slaves. During that tenure, he was instrumental in founding Howard University, which bears his name to this day. In 1874, he was appointed the commander of the army's Department of the Columbia at Fort Vancouver. It was in that capacity that he was named to the commission.

The commission arranged for a meeting with the nontreaty chiefs at Lapwai in an effort to resolve the dispute. In the commission's report,

General Oliver Otis Howard. *Courtesy of the Library of Congress.*

Ollokot. *Courtesy of Manuscripts, Archives and Special Collections, Washington State University Libraries.*

Howard attributed Joseph's unrelenting attachment to the band's ancestral lands to the Dreamers. The commission concluded that "if the principle usually applied by the government, of holding that the Indians with whom they have treaties are bound by the majority, is here applied, Joseph should be required to live within the limits of the present reservation." The commission recommended that the "Indian agent at Lapwai should be fully instructed to carry into execution these suggestions, relying at all times upon the department commander for aid when necessary."

When Joseph refused to leave the Wallowas, Joseph's brother Ollokot arranged another Lapwai meeting with Howard during April 1877, at which the respective positions of the government and the nontreaty chiefs could again be discussed. Howard repeated the government's position; Joseph's response was simple and direct:

> *Suppose a white man should come to me and say, "Joseph, I like your horses and want to buy them." I say to him, "No, my horses suit me, I will not sell them." Then he goes to my neighbor and says to him, "Joseph has some good horses. I want to buy them but he refuses to sell." My neighbor answers, "Pay me the money and I will sell you Joseph's horses." The white man returns to me and says, "Joseph, I have bought your horses and you must let me have them." If we sold our lands to the government, this is the way they were bought.*

An agreement was not reached, and the council was recessed until May. Things did not go well in May. Howard arrested Chief Too-hool-hool-zote, a crusty leader of the Dreamers, for his "insolence" and outspoken refusal to move to the reservation. It was downhill from there. Howard released Too-hool-hool-zote and gave the nontreaty Indians an ultimatum: voluntarily move to the reservation within thirty days, or the army would forcibly move them. Joseph, knowing they were outnumbered, agreed.

# War

Joseph had agreed to move to the reservation because he thought they would lose if they fought. He asked for more time so the band could round up its cattle and horses and not have to cross the rivers that were swollen with snow melt. Howard denied the request. Joseph returned to the Wallowas and told the band's members of his decision.

The logistics of the move were daunting. The spring roundup of cattle and horses had not yet occurred. They were still grazing in the meadows where the snow had receded. The men rounded up what stock they could find while the women prepared the families' personal possessions and food and shelter to sustain them during the trip.

Historian Cecil Dryden described the perils of crossing the Snake River:

> *It took time to construct rafts of tightly rolled skins lashed together, load them with the most precious possessions, including women and children, the old men, the sick and the crippled. These rafts were towed by horsemen as all were launched on the roily, turbulent river with its whirlpools, rings of dirty foam, and fallen trees, rising, plunging, rising again.*

# Frontier History Along Idaho's Clearwater River

The rafts were successfully towed across the river, but getting the animals across was a dismal endeavor. Again, historian Dryden:

> *The horses and cattle were rounded up in herds, then stampeded and driven at full speed down to the river margin and into the tumbling waters where they were compelled to swim or perish. The strong successfully buffeted the flood. But the frail cows, young calves, foals, pregnant mares were quickly swept downstream. The bloated bodies carried by the current farther downstream attested to the great loss sustained by Joseph's band.*
>
> *It was one river or large stream after another, although the Salmon River, being smaller, did not exact the same toll as the Snake. They continued through the gulches, over the cliffs, and up and down the mountains until they arrived, cold, wet and exhausted on the Camas Prairie, not far from Tolo Lake.*

Chief Whitebird. *Courtesy of Glenbow Archives NA-5501-8, Calgary, Alberta.*

By the time Joseph's band arrived on the prairie, Chief Too-hool-hool-zote and his Salmon River band and Chief Whitebird's band had joined them. The assembled bands numbered about seven hundred members, of whom not more than three hundred were warriors. These chiefs had not agreed with Joseph; they wanted to fight. While at the encampment, an elder in Whitebird's band taunted a young warrior whose father had been slain by a settler the year before.

Reacting to the taunts, the young warrior and two companions set out to find the settler. When they couldn't find him, they went to the hut of Richard Devine, a reclusive Englishman, and killed him.

Not satisfied with that, they went to the ranch of Henry Elfers, who had helped a man known for horse whipping Indians escape punishment, and killed him. They killed two more men that day at Elfers's ranch.

The next day, joined by more warriors, they killed bootlegger Samuel Benedict and stole his whiskey. They then went on a killing spree that cost several people their lives. Joseph decided he now had no choice but to fight. As historian Beal put it, "The war fever spread, and the Indian blood was on fire. He [Joseph] must either lead or step aside. He chose to defend his people and their cause."

When Howard heard about the rampage, he sent Company F of the First United States Cavalry under the command of Captain David Perry from Fort Lapwai to Grangeville. Perry and his ninety-nine men and the supply train force-marched to Grangeville. On their arrival, Perry learned there was an Indian encampment along Whitebird Creek and concluded they were probably the renegade warriors. He decided to engage them at Whitebird Canyon.

The Nez Perce were aware of the troop's advance to the canyon and prepared for the encounter. Joseph's brother, Ollokot, and Chief Two Moons positioned the warriors on the high ground in the canyon behind rock outcrops and brush. When the cavalry arrived in the canyon, the Nez Perce sent a small detachment with a truce flag to meet with Captain Perry. Rather than receive the group, an army scout fired on it. The warriors returned the fire and killed the bugler. The battle was on.

The soldiers were tired and inexperienced. With the bugler dead, Perry could not communicate orders. The warriors had the cavalry surrounded on the three sides of the canyon. They were able to fire at will with a devastating crossfire from their superior heights onto the flanks of the troops. It was a rout. Thirty-four soldiers were dead, and two soldiers and two volunteers were wounded. No Indian lives were lost, and only two were wounded.

Howard pursued the Nez Perce warriors with four hundred troops, packers and scouts. The warriors were joined by warriors from other bands and returning buffalo hunters. They set up a decoy that tricked Howard into crossing the Salmon, during which several cavalry horses were drowned. That allowed the warriors to cross the Camas Prairie on their way to the Clearwater River without a battle.

Joseph and his band of almost 200 warriors and 450 women, children and old men set up camp at the mouth of the South Fork near what is now Stites. It was a time of decision: should they fight or flee? Chief Looking Glass, who had remained neutral until Howard plundered his

village, gave a spirited argument for fighting, saying he had been betrayed by the whites.

When Howard's troops arrived at the cusp of the Clearwater canyon and saw the encampment, they waged a surprise attack. The warriors reacted swiftly. The battle continued into the night, and eventually the fighting stopped with neither side able to claim victory.

A council was called, and the discussion about how to proceed resumed. Joseph argued that they should fight, saying, "I would rather fight than run I know not where." The majority of chiefs, however, saw the odds as hopeless and argued for joining the Crows in Canada, out of the reach of the American government. Joseph acceded to the other chiefs and was appointed camp master, and Looking Glass was voted to be in charge overall.

At about the time the nontreaty Nez Perce were arriving at the Clearwater River, Patrick Gaffney and his son, Frank, rode their horses to Kamiah to purchase some cattle from the local Nez Perce, presumably for Patrick's butcher shop at Pierce City. They were surprised to see a war party, and their Nez Perce friends told them the nontreaty Nez Perce were on the warpath and might go to the Montana Territory by way of the Weippe Prairie and the Lolo trail that the Nez Perce traditionally used to cross the Bitterroot Mountains when they hunted buffalo. The Gaffneys hightailed it back to Pierce City to alert the local residents about the war party. At the same time, a Nez Perce woman from the Ahsahka–North Fork band named Louise, who sold vegetables to Pierce City customers, came to town and told the inhabitants of impending danger.

Frank Gaffney. *Courtesy of Virginia Gaffney Bird.*

The situation of the local population on the prairie and in Pierce City was dire. The individual ranchers would be no more of a match for the warriors than the Salmon River settlers had been. The white population at Pierce City was not more than twenty-five souls, and the three hundred or so Chinese miners

were neither armed nor inclined to fight. Given the remoteness of Pierce City, the whites had surprisingly few firearms available for them to defend themselves. Horatio Gray owned the only rifle in town, and Francis "Frank" Carle owned a shotgun that had only one lock. A few men had revolvers. And that was it.

As soon as the Gaffneys warned the ranchers about the danger, they headed for Pierce City. The Reeds, with whom young John and Josephine Molloy were staying, let the cattle, hogs and chickens out of their pens so they would be less likely to be stolen or killed by any marauding warriors who might come by. They then gathered up the food that had been set on the table, got in the wagon and drove to Pierce City. They were joined by Peter Hourcade, Martin Mauli, Wellington Landon and D.W.C. Dunwell, who had taken over the operation of the ferry at Greer.

The *History of North Idaho* recounts that Patrick and Bridget Gaffney and their children also went from the prairie to Pierce City with the others who fled there. Patrick Gaffney located his ranch land next to Wellington Landon's. Virginia Gaffney Bird, in her book *Patrick and Bridget Gaffney and Their Descendants*, documents the move to Weippe in 1880. It may be that the family was preparing the land for the move or that Patrick and Frank were in Kamiah getting cattle for Patrick's butcher shop at Pierce City.

Not knowing what the Indians' intentions were, the Pierce City inhabitants started to prepare for the worst and hope for the best. Frank Carle's house was on the flat coming into town, and it was decided to fortify it as the main defense to a possible attack. A stockade of cordwood eight feet high was built around the house and two water wells. A small log fort was

Frank Carle. *Courtesy of Clearwater Historical Society.*

also built on the hillside just east of town. Guards were stationed around town. The inhabitants decided, however, that if the Indians did arrive, they would try to make peace because they recognized that they were not capable of anything more than a token defense.

Ed Hammond, the early schoolteacher and miner, volunteered to go to Lewiston to get help. He got as far as the Weippe Prairie when he saw a Nez Perce encampment of teepees and Wellington Landon's house in ashes. (Local lore has it that the Duke saved his life by going out to the hog sty and covering himself with manure. It is a great story, but according to *History of North Idaho*, it doesn't pass the smell test.) Nearby, Hammond saw seventy to eighty warriors holding a council. Since an attack appeared to be imminent, Hammond raced back to town to alert everyone that the worst was apparently in the offing.

Nothing happened that night, but the next morning Chief Lawyer sent word that they should be prepared for an attack. That night, all the inhabitants of Pierce City left their homes and businesses and went into the woods. Young John Molloy, then a nine-year-old boy, recounted that the town was so completely deserted that it was eerie. To everyone's relief, nothing happened that night, but it was now abundantly clear that the situation was deadly serious.

John Greer. *Courtesy of Clearwater Historical Society.*

Keenly aware that one rifle, one shotgun and a couple of revolvers were no match for the seventy to eighty warriors Ed Hammond had seen near Wellington Landon's ranch, John Greer, Horatio Gray, Elliot Cole, Hiram Nelson, Patrick Keane, Frank Capps, Ed Hammond, Lawrence Dunwell and Robert Yantis decided to procure arms for the town's defense. Being without firearms, they were anxious to get to Lewiston without a hostile encounter, so they rode down Quartz Creek to the North Fork and then on into Lewiston. There they found the local merchants very sympathetic and quickly

acquired sixteen rifles and ample ammunition. Now armed, the men returned by way of Greer, where they found that the ferry had been cut loose and the adjoining lodging had been burned. They rafted the river and continued on to Pierce City without incident.

Despite the efforts of the stalwart men of Pierce City, not a single shot was exchanged between the Pierce City fathers and the Nez Perce warriors. Some friendly Nez Perce later told them that there had been a heated and prolonged argument at the warriors' council about whether the settlers and miners should be attacked. The warriors who had befriended whites during the gold rush ultimately prevailed, and armed conflict was never engaged. Joseph's famous 1,600-mile retreat soon followed. It ended just short of the Canadian border at the Battle of Big Hole.

## Crime and Punishment

Despite the fact that there had been a county courthouse since 1862, an active territorial government had been in place since 1863 and the Plummer gang had been chased out of the territory, the court system still was not always the first choice for resolving disputes. Claim jumpers in the diggings were viewed the same as cattle rustlers on the plains, and the disputes were often settled on the spot. Why waste time with a lot of legal formality? And summary proceedings were not limited to mining claims.

The Chinese were not the only ones subject to indiscriminate violence. The Indians were especially vulnerable because they had nowhere to go for recourse. Historian L.V. McWhorter, in his book, *Hear Me, My Chiefs: Nez Perce Legend and History*, related tribal historian John Allen's account of how bad it could be:

> *At Pierce City, one of the first mining camps, the wife of Jack Eemonwahtoe was killed in 1872 or in 1873. Some of the Indians raised small patches of wheat and vegetables and the old couple had brought some to exchange for gold dust or money, and they camped near the mines. The miners were drinking heavily and attacked Eemonwahtoe. His wife came to his rescue, not thinking that the miners would harm a woman, but one of them drove a miner's pick through her body, striking her in the back. She was killed instantly. No account was taken of this deed. Eemonwahtoe told about it when he reached home, but no authority listened to him. There was no law*

*against killing Indians. The* [Indian] *agent said he had no control over outside affairs.*

That is not to say that whites were exempt from sudden and arbitrary violence. They weren't. But the difference was when it happened to them, there was outrage. The *Idaho World*, published in Idaho City and one of Idaho's earliest and largest newspapers at the time, carried an article in November 1878 that brought that fact home beyond any doubt:

*The news has just been received here of a fatal affray at Pierce City, Idaho. [John J.] Molloy, sheriff of Shoshone County, and Charles Brown, became involved in a dispute and drew pistols. P. Streeter, of Lewiston, stepped between them, when Brown shot him in the neck. The Probate Judge fined Brown $5. Streeter died soon after. The miners have held an indignation meeting, and are threatening to lynch Brown and the Judge.*

So much for law and order! Seven years later, on September 10, 1885, the culture of ignoring the courts and law enforcement would lead to an international incident. The county seat had been transferred from Pierce City to Murray the year before because of the burgeoning population in the Coeur d' Alene mining district. By that time, almost all of the merchants at Pierce City were Chinese. One of the three general merchandise stores was owned by David Fraser, who had earlier operated a sawmill and was then operating his store.

Fraser was reputed for his honesty and fair dealings and

David Fraser. *Courtesy of Idaho State Historical Society.*

had served many years as a Shoshone County commissioner. Fraser's Panamanian wife had apparently died because he lived at the back of his store, had hired a Chinese woman as his housekeeper and took his meals at a local boardinghouse. His daughter, Alice, who had been the only girl in the first formal school in 1874, was living with friends in Lewiston while going to school.

The night of September 9 was stormy, and the Chinese had set off a lot of firecrackers, ostensibly to ward off evil spirits. John Molloy, a seventeen-year-old lad at the time, said it seemed like a Chinese New Year celebration. The next morning, Fraser did not show up for breakfast as usual, so the packer who hauled in Fraser's freight for him was sent to the store to see what was wrong. The *Lewiston Teller*'s article about the murder described the scene the packer found:

> [Fraser] *was found terribly chopped to pieces in his own store, with a large pool of blood near the body and another in his bed room—several yards distant—and a bullet hole in the mouth and coming out the side of the neck, with cuts of an axe and hatchet and knife in many places on the head, face and body and evidences that he had a terrible encounter with his murderers. The body was still warm and the bloody axe and hatchet nearby and bloody bare-foot tracks in both rooms and between the two...The scene was so appalling and bloody that the few white men living in town (only seven in number) were completely appalled.*

When news of the murder reached Lewiston and the Grangeville–Mount Idaho area, the local vigilance committees were quickly summoned. H.F. Church, a member of the Grangeville committee, said the Lewiston and Grangeville vigilantes together numbered sixty men by the time they met at the Gaffney ranch on the "Little Camas Prairie," as the Weippe Prairie was then called. John Bymaster, a Snake River raftsman and sawmill owner from Lewiston, was elected the captain of the committee, and a Lewiston jeweler named George B. Lake (sometimes mistakenly referred to as Blake) was elected lieutenant.

Church said that early in the morning "we rode into Pierce on the gallop, and when we reached the town we divided and surrounded the place." They found a crowd standing around two old Chinese men who were groveling on the ground while another middle-aged Chinese man was standing and accusing them of the foul deed. It turned out that the accuser was named Sam, who was one of two Chinese men from San Francisco representing the

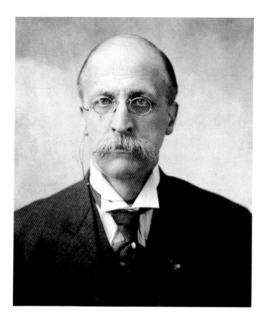

George Lake. *Courtesy of Nez Perce County Historical Society, Marcus Ware Family Collection 11-17-1.*

Six Companies that supplied and perhaps had an interest in the two Chinese stores.

The vigilantes decided a trial was needed. But it would be their trial, not the county's. And it would be held in a building of their choosing, not at the courthouse. And they would provide the judge, not the territory. So the stage was set.

The vigilance committee set up its court in a nearby empty building and organized itself for the trial. Lewiston committee member I.C. Hattabaugh was elected to be the judge, and Captain Bymaster acted as the prosecutor. Sam persisted in his story that he had seen the two old men leaving the Fraser store at four o'clock in the morning. The committee did not believe Sam, so the men took him to a tree at the end of the street and suspended him with a rope by the neck to try to scare him into the truth. He would be let down and then suspended again but to no avail. Finally, they laid him on the ground and covered him with a blanket. They then brought his colleague to the site. Upon seeing what he thought to be Sam's dead body, he accused him of the murder. Sam, hearing the accusation, rose from beneath the blanket and accused his accuser of the killing. The committee then put them both in the jail with the two old men.

The committee then persuaded Lonie Sears, one of the Grangeville vigilantes, to go into the jail posing as a drunken Indian. Unbeknownst to the Chinese prisoners, Sears understood Chinese from having lived with the Chinese in San Francisco or, as some said, having worked with them at the Warren diggings. In any event, the ruse worked. Sears learned that Sam and his San Francisco cohort were upset that half of the local Chinese were patronizing Fraser's store and decided to eliminate him as a competitor. To that end, according to Sears, they hired three local Chinese men—a gambler, a barber and a pimp—to murder Fraser. Sears said he learned how the deadly deed was done by listening to a quarrel between Sam and the murderers.

# A New Territory

Vigilante Church related Sears's understanding of what occurred:

> *The three* [hirelings] *got inside the store and one got an axe and hit Fraser on the head while he still had his head on the pillow. The bit of the axe was used. A lot of bloodstains were in evidence, some on the ceiling overhead. Fraser got up and fought his way into the store, grabbed a hatchet that hung beside the door, wounded one Chink, got behind the counter and was shot.*

Church said the blood smears inside the store confirmed the story because there was blood on the wall, blood beside the door where the hatchet had been and blood on the hatchet that was found beside Fraser's body.

There were other accounts about the motives for the murder. One theory was that the Chinese were adding gold-covered brass filings, called "bogus dust," to the gold they were using to pay the Indians who supplied much of the produce to the Pierce City stores, and Fraser had either told the Chinese he was on to their practice or he told the Indians who confronted the Chinese. Another theory was that the Chinese men resented the fact that Fraser had a Chinese housekeeper. Either version may have played a part.

The vigilance committee's court decided that the two San Francisco Chinese and their three hirelings were the culprits and apparently turned the prisoners over to the local authorities for trial. The two old men were released. Either the sheriff or the district court decided that a sheriff's detail should haul the prisoners to the county courthouse in Murray.

Eighteen-year-old Frank Gaffney was made a deputy sheriff to escort them on the trip, and William Curry, a local livery stables owner, who liked whiskey as much as he disliked baths, was chosen along with three other men to drive the wagon and guard the prisoners for the five-day trip.

When the wagon had traveled two or three miles south on the old Pierce City road, it was stopped by a large number of armed men who had gone to some lengths to disguise who they were. They ordered the sheriff's detail to return to Pierce City without the prisoners. Outmanned and outgunned, they complied. A pole was tied between two pines. Nooses were strung from the pole and placed around the prisoners' necks, and the men were hanged. Curry was paid five dollars a body to haul them back to Pierce City for burial.

The Chinese government lodged a formal protest with the United States State Department, which in turn initiated a formal investigation. In April 1886, the secretary of state requested Idaho territorial governor Edward Stevenson to investigate and report on the hangings. By then, an anti-Chinese sentiment had swept the territory, and the Boise Anti-Chinese League had

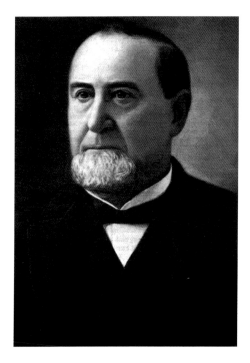

Governor Edward Stevenson. *Courtesy of the Idaho State Historical Society.*

set May 1, 1886, as the deadline for all Chinese to leave the territory peaceably or face forced expulsion. Not to be outdone, the *Idaho World* editorialized that the Chinese should be denied jobs and be ostracized or else the "Mongolians will become a fixture on this coast and remain a menace to labor and a nightmare to civilization."

Given the pervasive anti-Chinese sentiment, Governor Stevenson showed his mettle when he issued a strongly worded proclamation instructing all law officers "to use every precaution to prevent all riotous demonstrations." The proclamation had its desired effect. Violence was averted in large part due to Stevenson's popularity in the territory. He was a man the people felt they could trust because, unlike most territorial governors, he was one of them. He had come to Idaho Territory in 1863 to mine and made a fortune as a miner in the Boise Basin and as a rancher in the Payette Valley. When President Grover Cleveland appointed Stevenson, he became the first governor who was actually living in Idaho when he was appointed.

Governor Stevenson sent a delegation to Pierce City to personally investigate the hangings as he had been requested. After hearing from the stalwarts of Pierce City about what had occurred, he reported that the deputy sheriff and his posse "were so badly frightened on being suddenly surrounded by a large number of blackened, disguised, masked, armed men…they were unable to recognize any of the party." Stevenson acknowledged that the hanging had been a rash act, and while he regretted citizens had taken the law into their own hands, he had no doubt that those who were hanged "were the identical parties, who so cruelly, shockingly and brutally murdered, without the least provocation (except jealousy) one of the best citizens of Idaho." And the vigilantes lived to ride another day.

# 3
# THE FIGHT FOR STATEHOOD

## A False Start

By the 1880s, mining had declined in the Clearwater country to such an extent that there was talk of dissolving Shoshone County. Ed Hammond, the teacher-miner at Pierce City, was also the local correspondent for the early-day Lewiston newspaper, the *Lewiston Teller*. On July 21, 1881, the *Teller* reported how dire the situation in Shoshone County had become:

> Our Pierce City correspondent announces the partial disorganization of Shoshone, leaving the people of that county without any executive officers. For some time past offices in that county have been compelled to go begging for men to fill them, and after once being filled, several substitutions have been made after periods of interregnum. The whole number of white residents in the county seldom exceeds seventy-five persons, and is more often less than that. Hence the burdens of supporting a county organization have been quite heavy upon each individual for some time past.

The article continued that the ranchers were supplying an ever-decreasing number of miners and had no one to whom to sell their surplus, and there was no incentive, therefore, for newcomers to take up ranching. It also noted the effect of being within the boundaries of the 1863 reservation was the unavailability of that land for homesteading. The result was a population

too small, as the article put it, to even "make it practicable to secure an impartial jury."

This all changed for Shoshone County in 1882 when A.J. Prichard, R.T. Horn and a fellow named Gillette discovered gold on a tributary of the north fork of the Coeur d' Alene River, now known as Prichard Creek. The next summer, Prichard located a land claim near what became Murray. Publicizing the discovery led to a new stampede to the Coeur d' Alene. Eagle City was the first town laid out in the new mining district, but it was the discovery of lead and silver ore on the south fork of the Coeur d' Alene River that really spurred the development of northern Shoshone and Kootenai Counties.

By 1884, Murray and Eagle City were bustling mining towns. By the summer of 1884, there were over two thousand mining claims filed in the district, and Eagle City had become the new gold-rush town. The north Idaho pioneer newspaper, the *Coeur d' Alene Nugget*, said, "The most aggravating evil which vexes this camp at present is not poorly cooked beans, bad whiskey, dead beats nor the dreadful condition of our trails. All these are bad in their way, but are glorious when compared to the difficulty and uncertainty of receiving our mail."

There was talk of dividing the county and making the southern half part of Nez Perce County, but that idea was opposed by the few citizens still living in the southern part of the county. The population of Pierce City at that time ranged between 150 and 200 people. In 1884, the territorial legislature made Murray the temporary county seat and scheduled a vote on which town in the county should have that role. The election was held in June 1885, and Murray was chosen by a large majority over the mining camp of Delta. Pierce City was no longer the county seat, and Ed Hammond bought the Pierce City Courthouse for fifty dollars that summer.

As the population of the territory grew, so did the pressure for statehood. The obstacles to statehood were twofold: the northern counties wanted to be a part of a northern tier state, and the United States Congress would not agree to statehood unless the northern counties were included to temper the influence of the Mormons in southern Idaho. The gold discoveries at Wood River and Lemhi and Custer Counties, together with the building of the Utah Northern and the Oregon Short Line Railroads across the reach of the southern part of the territory, made the disparity in population between the north and the south even more pronounced. The growth of the Mormon communities in the Upper Snake River Basin at Rexburg and Eagle Rock (Idaho Falls) added to that trend. It became a battle between "North Idaho" and "South Idaho."

# The Fight for Statehood

As early as 1866, North Idaho residents had tried to form a new territory that would include eastern Washington Territory and western Montana Territory that would be called Columbia. The political power brokers at Boise, led by Milton Kelly of the *Idaho Statesman*, were able to abort that effort. That only fed the frustration of the North Idaho residents who felt they paid taxes to a distant, unresponsive government from which they received no benefits.

President Andrew Johnson had appointed Milton Kelly a territorial judge soon after the Civil War. Although a native of New York, once he arrived in Boise, he remained there the rest of his life. He lost his judicial appointment with the election of Ulysses Grant in 1868. He bought the *Idaho Tri-Weekly Statesman* in

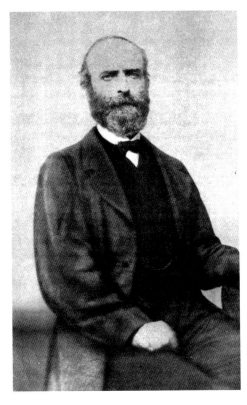

Milton Kelly. *Courtesy of Idaho State Historical Society.*

the early seventies, and from then on, he masterfully used the *Statesman* to manipulate Idaho politics for a generation. Idaho pioneer and historian Thomas Donaldson, in his book *Idaho of Yesterday*, said that Kelly was "vicious toward his enemies and he did not always discriminate as to who were really his enemies." He added that once Kelly acquired the paper, "he held a rod of terror over his enemies." He was very powerful. He was never popular.

Alonzo Leland, the Portland newspaperman who had publicized the Pierce discovery, had followed the miners to Lewiston and became the leading proponent of annexing North Idaho to the Washington Territory. He served in the territorial legislature and followed his newspaper calling as the editor of the *Lewiston Teller*. He used both venues to champion the annexation cause. The annexationists, as they became known, succeeded in getting the Washington and Idaho territorial legislatures to pass resolutions supporting

the change of boundaries to include North Idaho as a part of Washington Territory. The Idaho resolution, however, conditioned its support on the boundary change occurring only upon Washington Territory's admission as a state.

The near unanimity of North Idaho opinion for annexation with the Washington Territory fractured with the Coeur d' Alene discoveries. Many, if not most, of the miners in the Coeur d' Alene district came from the Montana Territory. They were quick to point out that the Washington Territory had no mines, and even worse, its residents favored women's suffrage and were under the spell of the farmers' grange movement. Additionally, the new Shoshone County seat of Murray was only seven miles from the Montana border.

The annexation issue became emotionally and politically polarized between the Palouse farmers of Latah County, who favored the Washington Territory, and the Coeur d' Alene miners of Shoshone County, who favored annexation to the Montana Territory. A compromise was proposed that would assign the Clearwater drainage to Washington, and the land north of the St. Joe River would go with Montana. By 1886, the House of Representatives had passed a Washington–North Idaho annexation bill. The idea of annexation was becoming more than just a North Idaho dream.

The Eagle Rock *Idaho Register* and the *Idaho Statesman* quickly kicked into gear an anti-annexation campaign. The Murray *Coeur d' Alene Record* also opposed joining Washington because it wanted to join Montana. The annexationists were furious. The Murray *Coeur d' Alene Sun* editorialized:

> [A]*ll the scribes have gone insane over the prospects of losing the panhandle. Not one journal is fair enough to accord the people of North Idaho a vestige of a right, from the mouthings of these hide-bound political hypocrites, who profess one thing in their conventions and practice the very opposite, it is beginning to appear as if the pan-handle was sort of a reservation for the slaves of Idaho.*

But the newspaper campaign, news of the dissention in the north and opposing petitions from the south prompted the United States Senate to stall the bill, and annexation was averted for the time being.

The next threat to the territorial integrity of the Idaho Territory came from Nevada. Nevada had become a state in 1864 to give the Republicans a much-needed state during the Civil War. But the Comstock Lode had petered out, and the state was strapped financially. Nevada's United States senator William M. Stewart proposed dividing the territory in half, moving

## The Fight for Statehood

Nevada's capital to Winnemucca and annexing South Idaho to Nevada and North Idaho to Washington.

Alonzo Leland gleefully supported the plan as the only hope of the people of the Idaho Territory to enjoy the benefits of statehood anytime soon. Milton Kelly countered with a spirited offense. He pointed out that in exchange for helping Nevada retire its debt, the Idaho Territory would lose its capital and territorial officers. He also charged that the people of South Idaho would become a part of a state that was, as historian Merle Wells put it, "controlled by the Central Pacific [Railroad] and a corrupt ring of San Francisco gamblers and speculators."

Not to be outdone, Senator Stewart got the Nevada legislature to pass a resolution in early 1887 approving the annexation of South Idaho. That was required because a state's boundaries could be changed only with the approval of the state involved, whereas the boundaries of a territory were a matter of congressional whim. Armed with his resolution, Senator Stewart went to Congress and persuaded the Senate to resurrect and approve the House bill annexing North Idaho to Washington Territory. Alonzo Leland exulted that the people of North Idaho were at last free of the "cold hearted, avaricious scheming leeches" of South Idaho and had been delivered from the "tyrannical, exacting masters" in Boise.

The final chapter, however, was written by Governor Stevenson, the Idaho pioneer from the Payette Valley who had been appointed governor by President Grover Cleveland. When the news of Senator Stewart's success in Congress reached Boise, Governor Stevenson telegraphed President Cleveland asking him for a leave of absence so he could go to Washington, D.C., to lobby him not to sign the bill. Senator Stewart and his Senate colleagues were also lobbying the president. The president promised Governor Stevenson that he would not sign the bill until the next Congress could better consider the choices. Congress adjourned a couple of days later, and the bill died with a pocket veto. Alonzo Leland lamented, "Here endeth another chapter in the wrongs inflicted upon North Idaho by the Boise ring."

## Those Mormon Democrats

Another dominant factor in the campaign for statehood was the battle over what role the members of the Church of Jesus Christ of Latter Day Saints should play in the political life of Idaho. The church was founded by Joseph

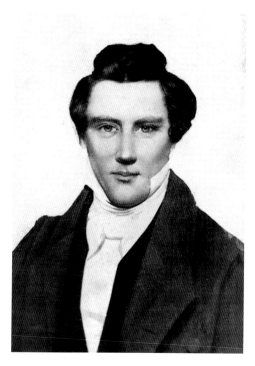
Joseph Smith. *Courtesy of the Library of Congress.*

Smith Jr. in New York State in 1830. Smith was the fourth child born to Joseph and Lucy Mack Smith in Sharon, Vermont, in 1805. The family moved to Palmyra, New York, where they farmed in poor circumstances. It was a time of great religious tumult and revival. Confused about what sect to join at the age of fourteen, Smith went into the woods to pray for an answer. He announced he had a vision of God and Jesus who told him not to join any sect. His assertion of a vision led to persecution that dogged him the rest of his life.

Three years later, he said an angel named Moroni appeared to him and told him where some gold plates were buried in a nearby hillside. He said he met there with the angel for four consecutive years, after which he got the plates that would be translated into the Book of Mormon using two transparent stones called Urim and Thummim that were fastened to the bow of a breastplate that was with the plates.

In 1827, Smith married Emma Hale. At about the same time, a youth named Oliver Cowdery, a schoolteacher, heard about the plates and sought out Smith. Cowdery wrote down what Smith said as he used the stones to translate the plates.

In 1829, when Smith and Cowdery came to the story of Jesus coming to America and about baptism, they went into the woods along the Susquehanna River and prayed for guidance about baptism. The men said John the Baptist appeared and laid his hands on their heads and restored the Aaronic Priesthood, and with that power, they baptized each other. Cowdery described what they experienced:

> On a sudden, as from the mist of eternity, the voice of the Redeemer spake peace to us, while the veil was parted and the angel of God came down

*clothed with glory, and delivered the anxiously looked for message, and the keys of the Gospel of repentance. What joy! What wonder! What amazement! While the world was racked and distracted…our eyes beheld and our ears heard.*

They reported that later, the Apostles Peter, James and John bestowed on them the Melchezedek Priesthood that Paul spoke about in the book of Hebrews, which enabled them to act as God's agents on earth to build the Kingdom of God.

A major tenet of the church and important to its experience in the Idaho Territory was that creation was the reorganization of already-existing matter and intelligence that were eternal and that humans existed as spirits who united eternally with their earthly bodies, thus leading to "the fullness of joy" that permits one to progress to godhood. Those who were endowed with the Melchezedek Priesthood received power commensurate with the original apostles that included the sealing power of Elijah to affect the afterlife such as sealed marriages that would continue after death and proxy baptisms for the dead.

Smith taught that the sealing of marriages and families was a part of the New and Everlasting Covenant that transcended all earthly bonds. The sealing involved a first ordinance by one authorized to solemnize eternal marriages in the temple and a second anointing by the Holy Spirit of Promise, which sealed married couples to their exaltation in heaven. He further taught that plural marriage was the ultimate validation of the New and Everlasting Covenant. Smith also declared during his 1840 campaign for president that the United States Constitution and the Bill of Rights were divinely inspired and were the Saints' best and perhaps only defense against oppression.

The Book of Mormon was published in 1830 and drew immediate attention and hostility. That scrutiny ultimately led Smith and Cowdery to lead the church first to Kirkland, Ohio, in 1831 and on to Missouri in 1838. Missouri was even more hostile than Ohio, which led to a battle between the Saints and the state militia. The governor then ordered them out of the state. In 1839, Smith and the now fourteen thousand converts moved to Illinois. They settled near the county seat of Carthage, where they established the city of Nauvoo, which is Hebrew for "to be beautiful." While there, Smith sent Brigham Young and others as missionaries to Europe, where they converted many poor factory workers. The membership grew accordingly.

The church was to learn that it had not escaped hostility by its move to Illinois. In 1844, Joseph Smith and his brother Hyrum were arrested for

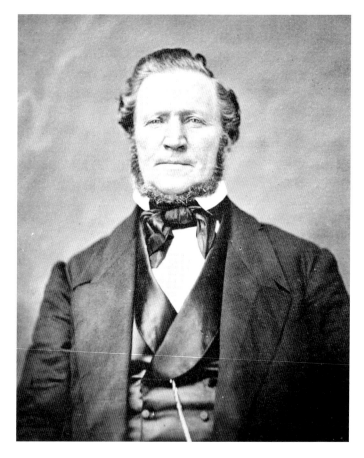

Brigham Young. *Courtesy of the Library of Congress.*

alleged crimes and jailed at the county jail at Carthage. While they were held there, a mob stormed the jail and murdered them.

Brigham Young was born in 1801 and converted to the faith in 1831. He was chosen to succeed Joseph Smith as the president and prophet. He proved to be a man of courage and organizational and administrative skills. Tired of being berated and harassed by unfriendly neighbors and mistreated by local government officials, Young decided to rid the church of these constraints by moving to an area where the church could govern itself unencumbered by hostile neighbors and unimpeded by secular governments. He had the far west scouted out in 1846 for a good place to locate and settled on the Wasatch Valley and the Great Salt Lake as sufficiently isolated to allow the church to govern itself without interference.

# The Fight for Statehood

The historic trek across the plains in 1847 was one of untold hardship and suffering. Once there, the Saints set about establishing their settlement. Young's plan was to start communities throughout the intermountain west. They would be populated by sending missionaries into all the reaches of the nation and Europe for the purpose of recruiting converts. Communities were soon established in what would become Utah, Idaho, Wyoming, Nevada and Arizona.

The church became the de facto government of what it called the State of Deseret, which encompassed the Great Basin and the entire Colorado River drainage. It included what became Nevada, Colorado, Wyoming and parts of Nebraska, Dakota and Idaho. Brigham Young unsuccessfully petitioned to have the State of Deseret admitted as a state. However, Congress created the Utah Territory out of the same area in 1850, and President Grant appointed Young the territorial governor. Any distinction there might have been between the church's government and the territory's government disappeared.

As the converts arrived, it was soon apparent that there were considerably more women than men. Only Brigham Young knows for sure whether that played a part in his 1852 announcement of the doctrine of the "Celestial Law of Marriage," which he said had been divinely revealed to Joseph Smith nine years earlier. The doctrine sanctioned plural marriages that were consecrated in heaven, contingent on the approval of the first wife. Many plural marriages followed. And Brigham Young practiced what he preached; he had fifty wives, fifteen of whom bore him forty-five children. It is estimated, however, that only 15 percent of the Mormon men had plural marriages.

While the church's legal authority to govern the territory continued, their members' remoteness from gentiles, as they called non-Mormons, was eroded with the discovery of gold at Sutter's mill in California in 1848. Salt Lake City became a major stopping-off point during the 1849 California gold rush. The Comstock Lode discovery in 1858 also brought in even more gentiles to the region, and Zebulon Pike's gold discovery of 1859 brought them into the eastern part of the territory.

The church was so concerned about the erosion of its isolation and independence that it was ambivalent about the transcontinental railroad's golden spike ceremony at Promontory Summit because it made access to the area easily available from both coasts. The creation of the Idaho Territory to include Wyoming and the admission to statehood of Nevada in 1864 and Colorado in 1876 reduced the Utah Territory to the state's present configuration, and that only enhanced the influx of non-Mormons into the region.

The first Mormon settlement in what became Idaho was started in the Lemhi Valley in 1856, but it was soon abandoned because of hostile Shoshonis. In 1860, the settlement at Franklin was founded, and it turned out to be just north of the Utah-Idaho border and became the first permanent white settlement in Idaho. As the converts arrived and the Mormon population grew, the towns of Malad and Soda Springs developed, and the new railroad towns of Eagle Rock and Blackfoot were established. As the communities prospered and the church's influence grew, anti-Mormon sentiment began to surface and polygamous marriages became the rallying cry.

The harbinger of things to come for the Idaho Saints was the congressional enactment of the Morrill Anti-Bigamy Act in 1862, which was initiated in response to the Mormon doctrine of plural and celestial marriages. Convictions, however, were rare, largely because the Mormon jurors refused to convict. The stage for the anti-Mormon movement was really set in 1880 when Republican president Rutherford Hayes asked for legislation unambiguously designed to suppress the Mormons' influence and political power in the Utah Territory and its neighboring territories.

Congress responded in 1882. It enacted the Edmunds-Tucker Act and refused to seat the Utah Territory congressional delegate, George Cannon. The Edmunds-Tucker Act forbade plural marriages and cohabitation with more than one woman. Polygamy was made a felony that was punishable by a fine of $500 and five years in prison, and cohabitation was a misdemeanor that was punishable by a fine of $300 and six months in jail. The act's constitutionality was challenged and upheld by the United States Supreme Court in 1884.

The territorial legislature followed suit and passed the Act for Holding Elections, commonly known as the Test Oath Act, in 1885, which provided that no person "who is a bigamist or polygamist, or who teaches, advises, counsels, or encourages any person or persons to become a bigamist or polygamist…or to enter into what is known as plural or celestial marriage… shall be permitted to vote at any election, or to hold any position or office of honor, trust or profit within the territory."

The act further stipulated that if an election judge challenged the right of a person to vote under the act, the person was required to sign an oath that he was not violating the prohibitions of the act before he could vote. He (only men could vote) then had two choices. He could perjure himself and swear that he did not belong to an organization that sanctioned plural or celestial marriages, or he could not vote. It did not matter whether or not the man himself had more than one wife. If found to have violated the act,

the person was guilty of a felony punishable by a sentence of not less than three nor more than ten years of incarceration.

The effect of denying Mormons the right to vote cannot be overstated. The large number of southerners who had migrated to the territory's mining camps during the Civil War voted solidly Democratic. That was especially true of the Confederate soldiers who had served under General Sterling Price and had been decisively defeated in Missouri in 1864, cementing the Union's control over Missouri. A large number of them made their way to the Idaho Territory, and they were not about to vote for the party of Lincoln.

The Mormons in the southeastern counties also voted Democratic as a block for several reasons. The Morrill Anti-Bigamy Act and the Edmunds-Tucker Act had been enacted by Republican Congresses and signed by Republican presidents. The Democrats of that day did not want government telling people what to do, and the Democratic delegate to Congress had defended the Mormons' right to practice their faith without government interference. As a result, the Democrats controlled the territorial elections from 1864 to 1880. Idaho Territory was solidly Democratic.

Yet at the national level, all the presidents since Lincoln were Republicans, and they would continue to be until the two terms of Grover Cleveland from 1885 to 1889 and 1893 to 1897. But the Democrats thought that Samuel Tilden's loss to Rutherford Hayes in 1876 was attributable to allowing Colorado statehood in August of that year.

Tilden had won the popular vote but lost the electoral vote by a margin of one vote. Colorado had cast its three votes for Hayes. Neither party would ever again let the admission of a territory have that kind of effect unless it was sure to work to its benefit. From that time on, no territory was granted statehood unless the president's party also controlled Congress and the territory that was seeking admission. It was apparent that Idaho would not achieve statehood as long as the Democrats governed it because there was no immediate prospect of a Democrat being elected president.

That same year, Republican Theodore Singser astonished the Idaho Democratic establishment when he defeated Democratic congressional delegate George Ainslie. Singser cleverly managed to cobble together the growing and largely anti-Mormon population that the railroads and irrigation farming had brought into South Idaho with the annexationists in North Idaho, whose desire to join the Washington Territory trumped their Democratic convictions. The absence of a congressional delegate to protect the Saints in Congress was matched by the appointment of Fred Dubois as the United States marshal.

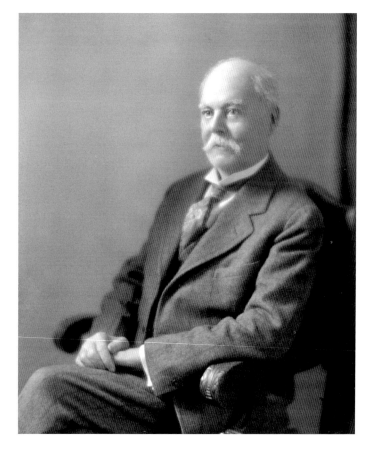

Fred Dubois. *Courtesy of the Library of Congress.*

Dubois was the grandson of a French Canadian immigrant who had distinguished himself in the Battle of Tippecanoe under the command of William Henry Harrison. He was the son of an Illinois judge and legislator who was a friend of Lincoln. He studied at Yale and became a businessman in Illinois. He and his brother, Jesse Dubois Jr., a physician, moved to Idaho Territory in 1880. Within two years as the United States marshal, he became the face of the anti-Mormon movement.

The territorial judges were appointed by the president and had jurisdiction over both federal and territorial criminal cases. In Idaho, there were three judicial districts and three judges who sat as both the federal trial judges in the districts and as the territorial Supreme Court justices. But it was the marshal who summoned the grand juries that decided who should be

charged with a criminal offence and the trial juries that decided innocence or guilt. Dubois undertook his duties with an uncommon passion.

Also arriving on the political scene at this time was William M. Bunn, the new territorial governor appointed by President Hayes. A woodcarver from Philadelphia who had served honorably during the Civil War, Bunn was involved in Philadelphia politics and ran a scandal-oriented newspaper before he was appointed to govern the territory. He was a dude in dress and demeanor. A friend described him as "neat in figure and clothes, rather daring at times in style and colors." Upon his arrival in Idaho, he joined the Republican juggernaut against the Saints. In his message to the legislature in December 1884, he urged it to "suppress these licentious saints with their plural marriages, and so wipe away the fetid blotch upon this Territory, that is a stench upon the nostrils of all honest humanity within our borders." The following year, he signed the Test Oath Act into law.

Dubois' prosecution of the Saints under the Edmunds-Tucker Act and the Test Oath Act was persistent to the point of being obsessive. He sent so many of them to the territorial prison that the overflow had to be confined in the Dakota Territory prison. Prosecutions were easy when it was the marshal who decided who would be called as jurors, a role from which the Saints were excluded by the Test Oath Act. He bragged that he didn't need any evidence to get a conviction.

There was little the Saints could do politically about their plight because the same act prevented them from voting. The Saints' resistance was ignited when Thomas Ricks took a courageous and principled stand. Ricks had converted at the age of sixteen in Illinois and was an inhabitant of Nauvoo, where he helped build the temple. On his trek across the plains in 1848, he was seriously injured by Indians from whom

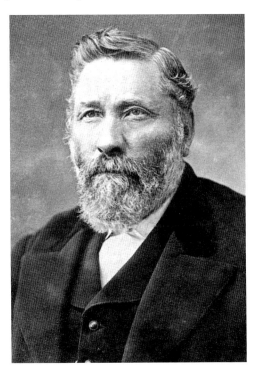

Thomas Ricks. *Courtesy of Brigham Young University–Idaho.*

he was trying to recover some stolen cattle. He is credited with founding the city of Rexburg, where he started the Bannock Stake Academy that evolved into Ricks College and is now Brigham Young University–Idaho. When the United States marshals tried to enter Ricks's home, he demanded a search warrant. The arrests decreased significantly after Ricks invoked his constitutional right to be free of unreasonable searches and seizures. His principled stance and its effects on their tormentors' tactics no doubt gave credence to Joseph Smith's declaration that the Constitution and the Bill of Rights were divinely inspired.

Given the Saints' unwavering support of the Democratic Party, they were disheartened by the North Idaho Democrats' decision to forsake them in exchange for Republican support of annexation. Equally dismaying was the decision of the Wood River Democrats to endorse a Democratic platform expressly condemning polygamy, albeit they didn't oppose their right to vote. They were being jailed and disenfranchised by their enemies and abandoned by their friends.

The irony was that the territory's Democratic politics had precluded statehood during the Republican administration of President Hayes, and its transformation as a Republican territory coincided with the election of Democratic president Grover Cleveland in 1884. The disenfranchisement of 25 percent of the territory's population to obtain a Republican majority and, in turn, achieve statehood had come to naught. Statehood would have to wait for another day.

Three events converged to enable statehood. Republican Benjamin Harrison was elected president in 1888, the South Idaho establishment bribed a North Idaho county into abandoning the annexation movement and joining the statehood campaign and the Mormon Church retreated from its plural marriage doctrine. Also important was Fred Dubois' election as the territorial delegate to Congress in 1886.

The election of a Republican delegate to the House of Representatives and the election of Republican Benjamin Harrison as president allowed Republican Dubois to use his considerable political skills to husband the statehood bill through Congress. In just two years, Dubois had formed several important political friendships, and it did not hurt that his grandfather had fought with the president's grandfather, former president William Henry Harrison, in the Battle of Tippecanoe.

Just when it appeared that all the stars were aligned for statehood, the Mormon legislature of the Utah Territory outlawed polygamy as a part of its bid for Utah statehood. The Mormon Church had signaled its abandonment of the tenet that had enabled the disenfranchisement of the Idaho Saints.

## The Fight for Statehood

All of a sudden, the Idaho Saints could sign the test oath and vote and put the territory's Republican credentials in doubt.

The Saints started registering to vote in droves. President Cleveland had earlier created the position of a territorial attorney general and appointed Richard Z. Johnson to that position. Johnson was born in Akron, Ohio, in 1837 and graduated from Yale Law School in 1859. He practiced in Minnesota for a while and then made his way to Nevada, and after a brief stay, he landed at Silver City, where he developed a flourishing law practice. Upon the decline of mining after a bank failure, he moved to Boise. He was appointed territorial attorney general in 1887. Johnson courageously decided that the Saints could not be prevented from voting and that their votes could be challenged only after they were cast. Desperate to preserve its bid for statehood, the legislature amended the Test Oath Act on January 20, 1889.

The amendment prevented anyone who had been a Mormon on January 1, 1888, from voting, holding office and serving as a juror. Its manifest purpose was to disenfranchise the Saints who had already registered to vote and to prevent them from voting in any future election. Despite his reservations about the retrospective aspect of the law, Democratic governor Stevenson signed it to preserve Idaho's bid for statehood. While it was not enforced, it maintained the façade of a Republican Idaho Territory.

But there still remained those pesky annexationists who continued to fight statehood. The Boise politicians had shrewdly learned how to deal with malcontents. There had been a movement to move the capital to Hailey when the Wood River gold rush made it a town of consequence. The Boise Ring quelled that drive by giving the big voting block at Blackfoot the insane asylum, as those institutions were called in those days. When it had looked like North Idaho would be annexed to the Washington Territory, plans had been made to establish the University of Idaho at Eagle Rock, but nothing had been done to implement them.

The two hotbeds of annexation were Moscow and Lewiston. Moscow, considered the less fervent of the two, was promised the state university if Latah County would join the statehood petition. The county agreed but only on the condition that the territory physically establish the university at Moscow before it would formally participate. When bricks were actually laid on Palouse soil in 1889, even Lewiston joined the petition for statehood.

Benjamin Harrison's defeat of Grover Cleveland in the election of 1888 ushered out Governor Stevenson and ushered in Governor George Shoup as the new territorial governor. Shoup, a native of Pennsylvania, had raised

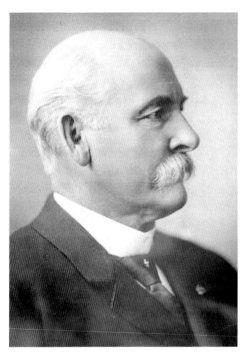

Governor George Shoup. *Courtesy of Idaho State Historical Society.*

cattle in Illinois before joining the gold rush to Pike's Peak in 1859. He owned a store that supplied the mines out of Denver. When the Civil War started, he served with the Colorado Volunteers as a colonel. When the war ended, he went to Virginia City in 1866 and worked as a merchant until gold was discovered at Leesburg over the continental divide in Idaho Territory. He opened a store there and permanently settled in Salmon the next year. There, he also raised cattle, was a commissioner of Lemhi County and served two terms in the territorial legislature.

With the advent of a Republican president, the annexationists in the fold and the Mormons in check, Idaho statehood looked like a sure thing. Governor Shoup oversaw the drafting of the Idaho State Constitution at the constitutional convention in Boise in 1889. The convention delegates incorporated the Test Oath Act into the constitution to remove any doubt about the territory's Republican persuasions. The voters of the territory ratified the constitution the same year. The following year, Idaho became the forty-third state on July 3, 1890. The Clearwater country was now a part of the Great State of Idaho. And the Gem State was now the forty-third star on Old Glory.

Ironically, Wilford Woodruff, the fourth and only foreign-born (England) president of the Mormon Church, would make the Idaho constitution's provision regarding plural marriage a dead letter when he issued a manifesto on October 6, 1890, ending the church's support of plural marriage and requiring Saints to comply with the laws regarding marriage existing in the areas where they lived.

# The Fight for Statehood

## The Homesteaders

While the battle for statehood was raging in the Idaho Territory, another battle over Indian lands was raging in Congress. Senator Henry Dawes of Massachusetts sponsored the General Allotment Act, commonly known as the Dawes Act, that provided the head of an Indian family would receive 160 acres, a single person or an orphan under the age of eighteen would receive 80 acres and all other persons under the age of eighteen would receive 40 acres, all of which would be held in trust for them by the government for twenty-five years. If selections were not made within four years, the government would make their selections for them, and citizenship would be conferred on those who chose the "habits of civilized life." After the Indians chose their allotments and a small amount of land was set aside for common use, the rest of the land could be purchased by the government and made available for homesteading.

Emily Greenwald in her book *Reconfiguring the Reservation* said the stated purpose of the act was:

> *Traits that Euroamericans associated with savagery—such as nomadism, collective economic strategies, and tribalism—would be replaced by traits associated with civilization—sedentary agriculture, private property, and individualism. The Dawes Act sought to atomize Indians, to break down their economic and social bonds by dispersing them onto individually owned parcels of land.*

Senator Henry Teller of Colorado argued that the purpose of the act was "to despoil the Indians of their land and to make them vagabonds on the face of the earth" and that its "real aim was to get at the Indian lands and open them up to settlement." He continued that the "provisions for the apparent benefit of the Indians are but the pretext to get at his lands and occupy them" and that if it were "done in the name of Greed, it would be bad enough; but to do it in the name of Humanity…is infinitely worse."

Congress passed the act in 1887. It was worded so that it would apply only to tribes chosen by the president, and President Cleveland put the Nez Perce on the list. The Nez Perce, for whom private ownership of property was an alien concept and who had not been told the legislation was being considered, bitterly opposed breaking up their land with allotments. The task of implementing the act fell on Alice Fletcher. Fletcher was the daughter of wealthy New Englander bluebloods. She was active in the New York City

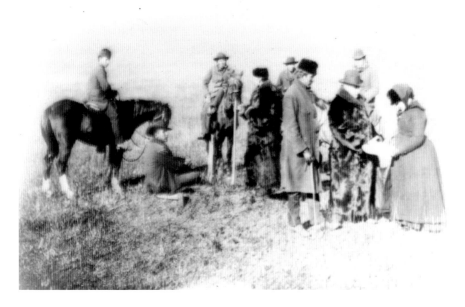

Alice Fletcher with surveyors. *Courtesy of Idaho State Historical Society.*

suffrage movement, and in the 1880s, she became interested in archaeology, which drew her to America's Indian tribes.

In 1888, the Bureau of Indian Affairs hired Fletcher to survey the allotment lands of those tribes selected for the program. In 1889, she was chosen to implement the program for the Nez Perce Reservation. She and her lifelong companion, Jane Gay, arrived in Lapwai only to run into some very unsympathetic Nez Perce. One tribal member commented, "How is it that we have not been consulted about this matter? Who made this law? We do not understand what you say. This is our land by long possession and by treaty. We are to be content as we are."

But Fletcher was persistent, and she concluded the project in 1895. The result was that 73 percent of the reservation was opened up to homesteading and other uses, and the Nez Perce were left with only 3 percent of the land that the treaty of 1855 had granted them. In exchange, they were paid $1,626,222, of which $626.22 was paid directly to each tribal member upon ratification of the program.

The effect for the settlers was that 542,064 acres were owned by the government and were potentially available for homesteading. The land for

homesteading was opened up on November 18, 1895. Overnight, the Fraser and Weippe Prairies were available. Many of the ranchers and farmers had filed "preemptions" on their places in anticipation of homesteading if the reservation opened up. They were quick to file. According to Robert Bailey in his book *River of No Return*, "It was but a few short hours before practically every piece of land had one or more claimants."

The settlers had been limited to fresh farm produce and animals that did not involve major disturbances to the land. Otherwise, they risked being removed from the reservation. Now they could clear and plow the land and raise grain crops. That ability ushered in the availability of a new economy. The fresh produce had been limited to local consumers. The science of canning was becoming common, but refrigeration was still limited to iceboxes and houses. The market for farm animals was also local because the railroad was not yet available to take live animals to bigger markets. Wheat, oats, barley and flax, on the other hand, could be hauled by wagon to a market or railhead or delivered downhill by a tram to a train along the railroad so they could be warehoused indefinitely in anticipation of better prices or a developing market.

The settlers who had "located" on the Weippe Prairie and in the Fraser area were among the first to file homestead claims on their existing ranches. It had also become clear to the families who had gone to Pierce City to mine that mining had no future for them if they did not move on to the next diggings. Many of them wanted to stay where they were and also decided to become homesteaders. A lot of new people would also come to the Clearwater country from as far away as Kansas and West Virginia looking for new opportunities as Idaho homesteaders.

The Weippe Prairie was mostly camas meadows that did not require a lot of clearing but did not lend themselves to grain farming. Many new settlers joined Wellington Landon and the Patrick Gaffney family in establishing ranches that raised hay, horses, cattle and hogs. Happily for them, the market for farm animals would increase with the arrival of the new homesteaders who would need saddle and draft horses for transportation and farm work and cattle and cows for meat and milk and to start their own herds.

Homesteading to raise grain involved an undertaking of an entirely different magnitude. Looming between the first stakes the homesteaders drove into the ground to locate their boundaries and their ability to plant their first seeds of grain was a virgin forest of old-growth yellow pine. Crosscut saws, axes, peaveys, oxen, horses, wagons and sleds were used to fell the trees and haul the logs. But it was men with brawn and women with grit

# Frontier History Along Idaho's Clearwater River

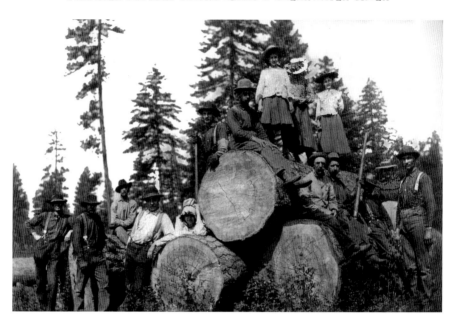

who made it happen. And not having much of anything, they didn't waste what they had. That included the trees.

Daniel Peckham started a sawmill on what is now Mill Road in Fraser. The logs were so big that, depending on the size of the wagon and the number of teams, only one log could be hauled to the mill at a time. Three logs made a very big load. Big loads were not easy to come by because getting large logs from the ground onto a wagon or sled was a tough task. The logs were not only big, they were heavy, and horses, ropes and muscle were all there was to lift them or get them into a position where they could be rolled from a dock or hillside onto a wagon. But once the homesteaders got the logs to the mill, they got boards in return for the price of having them sawed.

But there was still a huge hurdle—stumps. Roy Cochrell, the son of an early Fraser farming family, recounted that as a child, he could walk from the farmhouse to the schoolhouse by stepping from one yellow pine stump to the next. Clarabelle Judd Brown, the granddaughter of Fred and Claudia Judd, who arrived in Fraser from Iowa by way of Moscow in 1893, described what it took to wrest the stumps from the prairie soil. While dynamite was occasionally used, and sometimes a horse team could pull them out, they were usually burned out. The rancher would set them afire and then cover them with manure. The embers would then follow the wood and resin throughout the stump and its root system until there was nothing left but ash.

The boards sawed at the Peckham mill were used to build the houses, barns, schools and other buildings that replaced the log structures that

*Opposite, top*: A load of logs at the Peckham sawmill. *Courtesy of Marjie Johnson, Viola Molloy Collection.*

*Left*: Lumber at the Peckham sawmill. *Courtesy of Marjie Johnson, Viola Molloy Collection.*

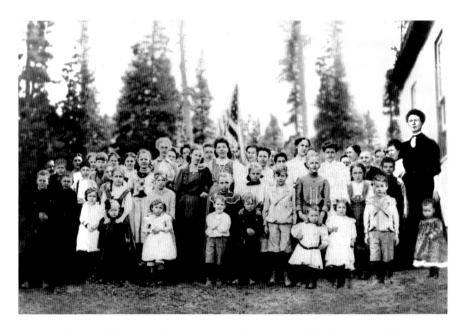

Schoolchildren at Johnstown School, circa 1908. *Courtesy of Marjie Johnson, Viola Molloy Collection.*

preceded them, although logs were still preferred in some instances, such as the church in Fraser. Most farms had a milk cow or two, raised hogs for meat, ran some cattle and, of course, had a flock of chickens. The wives planted big gardens. Because they could survive the tough prairie winters, apple trees and rhubarb plants were common sources of fruit, and lilac bushes gave the homesteads some color.

Most of the vegetables and fruit and some meats were preserved by canning. Icehouses were common. They were built with double walls filled with sawdust. During the winter, the men would cut the ice into blocks with a one-handled saw, lift them onto a sled with ice tongs and haul them to the icehouse, which also had sawdust inside to help insulate ice from the summer heat. Many families also had a smokehouse to preserve pork, especially for hams, bacon and sausage.

In Fraser's heyday, there was a store, church, post office and five schools: the Fraser School, the Okay School, the Johnstown School (named after John Molloy, John Snyder, John Stuart and John Strauss, whose ranches cornered at the school), the Cottonwood School (which had a high school and gym) and the Gray Eagle School (which was at the top of the old Greer Grade). Patrick Keane, who had traded mining at Pierce City for homesteading on

the prairie, ran the post office. A trading post also served the early community of Fraser, which, according to Claud Judd in his book *Judds in Fraser, Idaho*, was either owned or operated for a while by David Fraser, for whom the community was named.

Early homesteaders in the Fraser and Weippe area started work before dawn and finished after dusk. Even during the winter when there was not a lot to do but milk the cows and feed the stock, there seemed to be no end to the chores. But there had to be more to life than the seemingly endless and sometimes numbing labor. Besides making babies, there were dances and cards. Pinochle was the card game of choice, and games were easy to come by and would go on for hours.

But it was the dances that were a big deal. Young John Molloy's wife, Viola, said on a Friday or Saturday night, they would milk the cows, hook the horses up to the sleigh, dress the children warmly and then take off for the house where the dance was being held. Clarabelle Judd Brown remembers her parents heating bricks in hot water and taking them on the sleigh to keep everyone warm during the ride. The younger children would be put to bed, the rugs would be rolled up and the music would begin. The musicians were

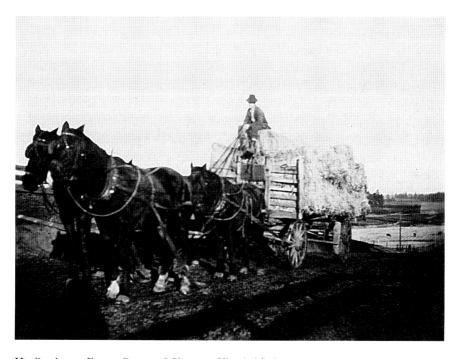

Hauling hay at Fraser. *Courtesy of Clearwater Historical Society.*

local people, most of whom were self-taught. Fred Judd was renowned for his fiddle playing. His son, Lawrence, would later follow suit with the fiddle and the harmonica. The folks would then dance through the night, and as dawn approached, they would hitch up the horses, round up the kids and return to their farms, where they would again milk the cows and, sated from a night of good old-fashioned hoedown, go to bed.

The settlers were as generous as they were fun loving. Don Wilson tells a touching story about his grandparents, Thomas and Mary Wilson. They headed west from Cedar Rapids, Iowa, in 1889 in a covered wagon with four small children—three boys and a baby girl. When they got to the Boise Basin, it was fall, and they worked in the harvest to get enough money for groceries so they could continue on to the Weippe Prairie. Mary wanted to stay in Boise for the winter, but Thomas was anxious to trudge on so they could get settled, so on they went. By the time they arrived at the Greer ferry, it was late fall. They crossed the river, and after paying for the ferry crossing, Thomas had one silver dollar left in his pocket.

The team pulled the wagon up the old Greer grade, and they arrived at the Clint Perkins homestead. Clint asked Thomas where they were headed, and Thomas told him they were on their way to the Weippe Prairie to locate a homestead. Clint said, "Don't go there this time of year because winter will be on you before you can get a cabin built; you won't make it through the winter." Clint then took the family in the Perkinses' house, hung a blanket or tarp down the middle of the living room and said, "This half is yours for the winter." The next spring, the Wilsons ventured on to the Weippe Prairie, where their fifth child and Don's father, Harve, was born and became the first white child born at Weippe.

Harve left home at age fifteen weighing about 135 pounds to be a freighter. He drove a freight team from Kendrick to Pierce City. Even though he was not supposed to be in a building where liquor was sold, one of the Chinese merchants would let him in his saloon to go to the back where the men sat around a big wood stove. His son, Don, known as Sonny, was a popular and longtime Seventh Day Adventist minister in north central Idaho and Montana. While he was stationed at Bozeman, he pastored the surrounding area that included the Robbers' Roost, a log building out of Virginia City where Henry Plummer and his gang had held out until they met their end with a long drop at the end of a short rope. Pastor Wilson started a Bible study group that met at the Robbers' Roost. One can only guess who was more surprised—God or Henry Plummer's ghost.

The Fight for Statehood

# The Pioneer Towns

The first town to prosper and grow with the arrival of the homesteaders was Greer. It became the shipping and commercial center for both the mines and the farms and ranches. It was the funnel through which all of the freight wagons and pack strings had to go to haul supplies into Fraser, Weippe and Pierce City. But it also was the natural place to haul and store the grain that was grown on the prairie and was destined for market. In 1890, John Greer and some homesteaders built a new road to the prairie that provided better access than the old Pierce City road.

John Greer was born in Pennsylvania to Irish immigrant parents in 1836. He was reared in Ohio, and in 1854 at the age of nineteen, he drove a team of oxen to California. He mined at Placerville and Hangtown and later in Shasta County until 1860, when he made his way to Pierce City. He mined there for ten years and then located a farm at Greer.

In 1877, after the Nez Perce had cut the ferry loose and burned the way station, Greer and John J. Molloy bought the ferry operation from Dennis Dunwell, a hard-luck guy from New York State. During the economic crash of 1857, he lost the fortune he had made as a grain and cattle broker in Minnesota. The *History of North Idaho* said that since the purchase, Greer "has been the ferryman and everybody for many miles distant know him as an affable and genial gentleman." It must have been true because the local people named the town after him. Although, it should also be noted that he donated the land that became the town site.

Horace Gamble, who had homesteaded at Fraser, ran a general merchandise store, and his brother, John, ran the Greer livery stable. John later joined his brother at the store, and Charles Stenzel took over the livery stable. William Varner and John Bush ran the blacksmith shop. There were two hotels—the Greer Hotel and the Montana a barbershop, a drugstore and a confectionary store where cigars were also sold. In 1902, a schoolhouse was built, and schoolteacher Lulu Palmerton had fifteen students. Patrick Keane moved down from the Fraser Post Office to run the one in Greer.

Another prominent merchant was George Erb, who opened a hardware store with his brothers in 1901. Erb was born in Missouri in 1866. His father fought for the Confederacy and then worked as an Indian scout. Following his death, George's mother moved the family to Weston, Oregon, and young Erb snowshoed from there to Lewiston in 1889. While at Lewiston, he taught school; was elected probate judge, school superintendent and mayor;

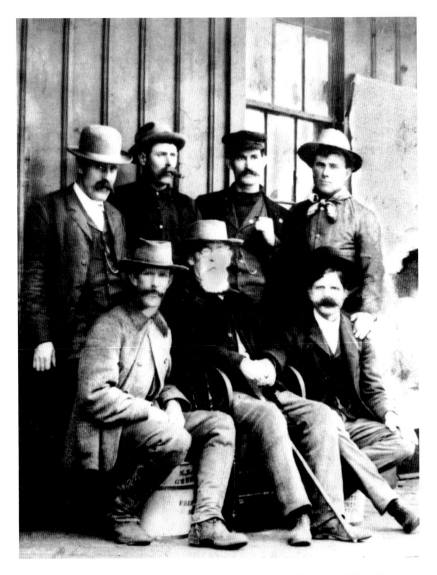

Greer pioneers. *Left to right*: J.S. Young, Frank Gaffney, Charlie Stenzel, John Greer, Mr. Hall, Matt Erb, John Smolinski. *Courtesy of Virginia Gaffney Bird.*

chaired the central committee of the Democratic Party; and was a trustee of the Normal School.

Erb left all his political and commercial activities behind for the attractions of the bustling town of Greer. But it turned out that he was attracted to more than just Greer. The next year, he married Mary Dowd, the daughter

# The Fight for Statehood

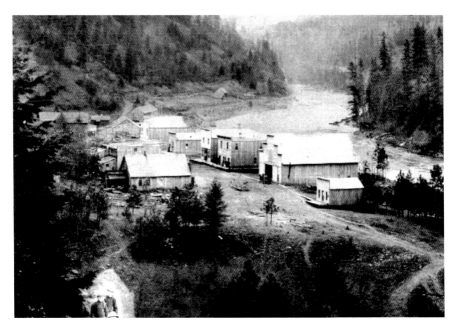

Town of Greer. *Courtesy of Clearwater Historical Society.*

of Irish immigrants Michael and Elizabeth Dowd. Before homesteading at Fraser, Michael Dowd had worked as a pioneer blacksmith at Pierce City during the gold rush.

Central to the town's growth were the Northern Pacific Railroad and the two large grain warehouses. The railroad arrived in 1899 and hired J.S. Young as the depot agent. Volmer Clearwater Company of Lewiston and Kerr Gifford and Company of Portland owned the warehouses. It is remarkable how soon the homesteaders started producing commercial quantities of crops.

By 1902, the farmers on the Nez Perce Prairie, as the Fraser prairie was then called, were doing some serious farming. Matt Erb, George's brother, managed the Volmer Clearwater warehouse, which had three-fifths of the business. He told the *History of North Idaho* that that year, the company "purchased 5,554 sacks of wheat, 12,271 sacks of flax, 4,387 sacks of oats and 4,459 sacks of barley, practically all of which came from the Nez Perce prairie."

At the same time, what had started as the Wellington Landon and Patrick Gaffney ranches was becoming a small trading center for the prairie. When Patrick Gaffney became the first postmaster, the town needed a name, and he was the one who chose Weippe, which was how the area had been identified

in the Nez Perce treaty of 1863. He sent the name to the postmaster general in Washington, D.C., and the town has enjoyed that moniker ever since.

By 1890, Weippe had 156 residents. Five years later, the residents built a schoolhouse, and by 1900, Miss Coontz was teaching 18 students. Patrick and Bridget Gaffney's son, Frank, was a member of the first class to graduate from the school. He was acknowledged to be the best student and most gifted athlete to graduate that year. He also happened to be the only student to graduate that year.

As the community developed, so did its businesses. R.J. Anderson and a quite young Frank Gaffney opened a general store; Wellington Landon ran a small café; John Tary had the blacksmith shop; and W.W. Gardner was the proprietor of the Weippe Hotel and the livery barn. Anderson also owned a sawmill near town that employed many men and turned out sixteen thousand board feet of lumber a day. Three and a half miles west of town, the Barry brothers competed with a smaller mill.

As births occurred, so did deaths. That led to the creation of a cemetery district. One of the members of the district's board was Charlie Huckleberry. Huckleberry had been born in 1852, reared in Indiana and had worked as a ranch hand in Kansas, Missouri and Illinois before he made his way to Troy, Idaho, in 1884 and on to Weippe in 1897. He owned a quarter section of land just out of town and was known to be a devout Methodist. Local Weippe historian Everett Martin tells the story about when a member of the cemetery district proposed that they put a fence around the cemetery. Huckleberry is reported to have said, "That's the craziest idea I ever heard of. The people who are in there can't get out and those who aren't there don't want in."

The present town of Orofino had a more roundabout start. The Nez Perce Ahsahka band was at the mouth of the North Fork of the Clearwater. The mouth of Oro Fino Creek was very much a part of that band's territory. Settling there was not an option. The reservation was respected—sort of. The first thrust toward the mouth of Oro Fino Creek happened during the early 1880s. John T. Molloy wrote about the venture in his memoir, *Passing of the Pioneers*:

> *C.D. Jones, H.L. Gray, Theo Thompkins and others settled on Orofino Creek 6 miles above Orofino, calling it "Hell's Delight" because it was Hell to get into. They cut a trail from Fraser across Ford's Creek and packed their supplies and families in on horses. They afterward made a trail down Orofino Creek to the Clearwater River where Orofino now stands.*

# The Fight for Statehood

*They packed in their supplies from Lewiston and later Kendrick, stopping en route at Mr. and Mrs. Hogue's road house, one mile above Ahsahka, enjoying their hospitality.*

Christian Jones is another example of the grit and guts it took to survive in those days. Born in Wales in 1824, his mother died when he was one year old, and his father, a sea captain, drowned when he was two. His brother reared him aboard sailing ships, and he saw most of the world at a very young age. He arrived at San Francisco in 1849 as a mate aboard a bark. He left the ship for mining and did so well that he bought a schooner, which he had to beach on its first voyage to save the crew.

After Jones lost his ship, he went back to mining, married and had a daughter, whom he took with him when he left his wife in San Francisco. His daughter went on to become a successful physician in Chicago. In 1861, Jones came to Pierce City, where he mined until 1865, when he went prospecting in Ecuador, Peru and Colombia. He returned to the States and mined until he came back to Pierce City in 1881. He then went to Hell's Delight, where he ranched for the rest of his years.

For many years, an Indian named Hale Moody from a Montana tribe had lived and claimed about 140 acres of the land in the valley at the mouth of Oro Fino Creek. Before the area was opened up to homesteading, Moody transferred the land to Benjamin Hines, who was married to a Nez Perce woman. Another Nez Perce woman named Ka-las-poo selected as her allotment a major part of the bottom land. That didn't leave anything for a town site.

A fellow named Clifford C. Fuller came to Oro Fino's rescue when he arrived on the scene in 1895. Fuller was born in Michigan in 1868. His family moved to Huron, South Dakota, and he then moved on to Olympia in 1890, only to move on to the mouth of Oro Fino Creek when the reservation opened up to homesteading. He homesteaded the remaining strip of land along the Clearwater River and Oro Fino Creek. He then commuted his homestead filing, and in 1898, he formed the Clearwater Development Company for the purpose of laying out a town site and building a ferry at the mouth of the creek. The town site was platted that year, and a ferry was built. William Chandler, a former Indian fighter whose parents had driven an ox team to California in 1849, operated the ferry. Also built that year was a rough wagon road to the top of the west side of the canyon. Hell's Delight's trail became a road. Fuller wasted no time establishing a trading post just a few yards from the river.

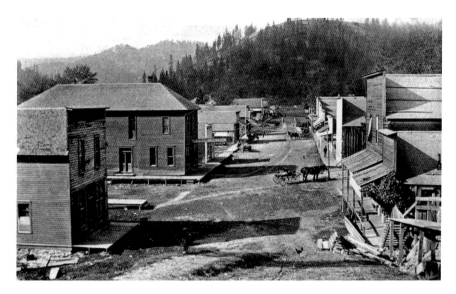

*Above*: Early Orofino. *Courtesy of Clearwater Historical Society.*

*Left*: Charles Moody. *Courtesy of Clearwater Historical Society.*

Charles S. Moody soon bought Fuller's store and moved it farther west, where he opened a drugstore and, with his parents, George and Mary Moody, ran a general merchandise store and a harness shop. Moody was born in Missouri in 1869 and moved with his folks to Oregon and then on to a timber claim out of Moscow in 1881. While living there, he got his teacher's degree and founded the Troy weekly newspaper, the *Alliance Ledger*, which he and his wife, Sophie, published for three years.

## The Fight for Statehood

The Moodys moved to the fledgling settlement that was being called Oro Fino in 1895. The drugstore business interested him in medicine, and he earned his medical degree from Central Medical College of St. Joseph, Missouri, in 1900. He moved to Sandpoint in 1901 to practice medicine, and fifteen years later, Governor Moses Alexander appointed him adjutant general for Idaho.

Fuller and Moody figured out that Oro Fino's success as a commercial center depended on getting a direct transportation route to Lewiston. The river was the obvious choice. Once Fuller got established, he chartered the steamboat *Lewiston* to come to Oro Fino to prove it could be done and shipped a load of cordwood back to Lewiston to help pay for the venture. That demonstration was instrumental in getting the Idaho and Washington Transportation Company to build the steamboat *Hannaford* to provide water transportation from the mouth of Potlatch Creek to the upper Clearwater. But before construction of the boat was finished, the Northern Pacific Railway Company bought it. It then brought the railroad to Oro Fino the next year, 1899. The *Hannaford* made four trips and was then relegated to navigate the Snake River.

The construction of the railroad was a real boon to the town because it brought about one thousand men to Oro Fino to build it. A payroll of that size attracted merchants like a magnet. Before the men and the merchants arrived, Oro Fino consisted of the Fuller house, the Moody stores, another store owned by John Beuscher, a small cabin that rented rooms owned by John Rowland and a post office with Lois Anderson as the postmistress. And when Ms. Anderson went to register the name Oro Fino with the postmaster general's office, she was told that it no longer accepted names that had two parts. Oro Fino became Orofino.

As the merchants arrived, the Orofino Commercial Club was started; Horace and James Greer started Orofino's first newspaper, the *Courier*; E.R. Reed built the Buckhorn Hotel; the next year, 1899, Horace Noble built the Noble House hotel; and Hunsperger and Boehl started a sawmill. The first school was held in a small frame building at which Sophie Moody was the first teacher, followed by Anna Tierney the next year. In 1902, the first schoolhouse was built at a cost of $1,850, for which bonds were issued. A testament to its need was the fact that I.F. Couch and Ms. Jesse Havernick taught 113 students there its first year. Also new to town were the Methodist church and its pastor, T.C. Craig.

At about the same time, there was a migration of families from West Virginia to Fraser, led by Sampson Snyder. Snyder was born to Sampson

Sampson Snyder (left) and employees. *Courtesy of Clearwater Historical Society.*

and Elizabeth Bonner Snyder in Randolph County in 1868. His father and grandfather fought for the Union with the Thirty-second Ohio Volunteer Infantry. In 1891, Snyder made his way to Nampa and then on to Moscow and from there on to Fraser, where he homesteaded a quarter section of land. The Carr and the Bonner families would soon follow him out to Fraser and also take up homesteading.

Sampson Snyder was a born entrepreneur. After building his homestead into a 480-acre ranch of hay land, an orchard and yellow pine timberland, he opened a hotel in Pierce City and then started a general merchandise store that catered to miners. He was one of the original investors in the first Orofino bank and owned the first telephone exchange and the first car dealership. He married Elizabeth Clark of Weippe, and they had six children: Vergie, Erma, Oro Lolo, Pearl, Eldon and Pick. He had an uncanny knack for staying ahead of the curve.

Orofino's future would be dramatically affected in 1905. The young state of Idaho discovered that the Idaho Insane Asylum at Blackfoot was inadequate to serve the needs of the insane. In 1905, the legislature authorized the building of the North Idaho Insane Asylum and a bond issue of $30,000 for its construction. It also set aside 40,000 acres of the federal land it had received upon becoming a state to establish a permanent fund for

its operation. The legislation also set up a committee headed by the governor to decide where it would be built. After reviewing several possible sites, it chose 245 acres of unimproved land just downriver from Orofino.

The man chosen to build and operate the hospital was Idaho's first alienist (as psychiatrists were then called), Dr. John W. Givens. Givens was born in 1854 to Mary and Thomas Jefferson Givens at Placerville, California, where they had come from Illinois during the gold rush of 1849. Thomas died soon after John's birth, and Mary returned to Illinois, where she remarried. The family crossed the plains again in 1862 to Oregon, where John was reared. As it was with Charles Moody, so also was it with John Givens, whose interest in medicine was whetted by his work at a local pharmacy.

John Givens. *From* Doctors with Buggies, Snowshoes and Planes.

Givens studied medicine at Willamette University and got his degree in 1875. He then married Ellen Luelling and went to work as a physician for the United States Indian Service in the Puget Sound region. He quit in 1882 to again study medicine at New York's Bellevue Medical College, where he obtained a second medical degree the following year. After a four-year stint at the Oregon Insane Asylum in Salem and a nine-year stint at the asylum in Blackfoot, he completed a postgraduate program in nerve and mental diseases at Johns Hopkins Medical College in Baltimore. After a year of private practice in Los Angeles, he returned in 1898 to Blackfoot, where he served as the medical director.

Dr. Givens was not only a gifted healer, he was also a remarkable architect and builder. He proved his mettle at Blackfoot when the hospital burned down and he oversaw its reconstruction by the patients, which included them making their own bricks. Historian James Hawley described his 1905 trek from Blackfoot to Orofino: "Taking with him twenty men and five women

patients whose insanity was of the mild type, with horses, wagons and the necessary implements, tents for shelter, etc., he commenced clearing ground and planting fruit trees. Within a year of when the location was selected the institution was ready for the reception of patients." And again, it was Givens who designed the buildings, and it was the patients who made the bricks and erected the buildings. Dr. Givens settled in at Orofino and ran the asylum for the next twenty years. Orofino was now on the map.

# 4
# THE NEW BONANZA

## The Timber Barons

A fellow named Charles O. Brown became interested in Idaho when he met his Civil War acquaintance Idaho governor William McConnell in 1893 at the Chicago World's Fair. McConnell's raving about the majestic timber stands in Idaho caught Brown's ear. Brown was born in Maine in 1842. He joined the Union army as a lieutenant in 1861 and wasted away to eighty pounds as a Confederate prisoner. Following the war, he married Clara Edwina Scribner, and together, they ventured to Pennsylvania and then Michigan in 1887 where he worked as a cruiser, scaler and buyer and seller of timberland. His son, Nat Brown, started helping him cruise timber at the age of fifteen and then worked as a scaler in the Michigan logging camps.

While logging in Michigan, the Browns met a young German immigrant named Theodore Fohl. Fohl was born in Germany in 1863, and in 1878, he left his parents and their small dairy herd behind and immigrated to the States as a fifteen-year-old lad. Fohl landed at Toledo, Ohio, and then moved on to the Upper Peninsula of Michigan, where he homesteaded 160 acres, worked at a sawmill, operated a shingle mill and cleared some of his land with a team of oxen. Then he started logging, which was in its heyday in Michigan.

In 1894, Charles and Nat Brown and Fohl decided to see for themselves if Idaho measured up to the vision Governor McConnell had planted in the mind's eye of his friend Charlie Brown. They took the train to Boise and

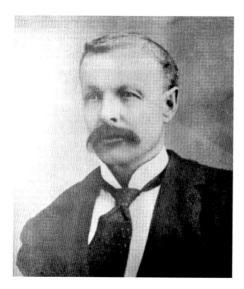

Charles O. Brown. *From* White Pines and Fires.

Theodore Fohl. *Courtesy of Clearwater Historical Society.*

met the governor, who urged them to head north. They hired a team and buggy and started out. They went up the Payette River, past Payette Lake and on into Moscow. Brown estimated that by the time he got to Moscow, he had seen over five hundred million board feet of timber. But none of that prepared them for what they would see in the drainage of the North Fork of the Clearwater River.

Soon after arriving at Moscow, they located homesteads just east of Bovill, and they discovered it would have been almost impossible for the governor to exaggerate what was probably the finest low-elevation forest in the country. Not only was it a huge white pine forest, but the trees themselves were also huge. On Fohl's homestead was one of the biggest white pines in the country. It was a 445-year-old, 227-foot-tall tree that scaled out at 28,900 board feet. Other white pines of that size class were found in the upper Scofield Creek, Washington Creek and Reed's Creek drainages. One tree northeast of Dull Axe Mountain out of Headquarters was struck by lightning. It turned out to have a seventy-five-inch stump diameter, a fifty-inch diameter 90 feet up and was more than 200 feet tall.

The vast timberlands of the Clearwater offered no opportunity for the Browns and Fohl because they did not have the resources to take advantage of them. So Brown began a campaign

to lure timber barons from Michigan, Minnesota and Wisconsin to Idaho. He wrote brochures; he traveled back to see them; and he cajoled anyone else he thought could commercially exploit the timber he had discovered in Idaho. The depression of 1893 had stifled the lumber market, and money was tight. But if Brown was anything, he was persistent. He eventually lured Edward Scofield and Frederick Weyerhaeuser out to take a look.

Edward Scofield was born in Pennsylvania in 1842. He fought with the Eleventh Pennsylvania Reserve Regiment in the Civil War, during which he earned a battlefield commission as a captain and was later promoted to major. He was taken prisoner just before the war ended. Following the war, he made his way to Wisconsin, where he made a fortune as a lumberman. He was elected governor in 1897 and served two two-year terms. He and his son, George, together with other wealthy Wisconsin lumbermen, including Warren McChord, became interested in Idaho.

Frederick Weyerhaeuser also became a major player in the destiny of the Clearwater drainage. He was born near the town of Mainz in the Rhine Valley of Germany in 1834 as one of eleven children. He started working on his father's farm when he was eight years old, and his father died when he was twelve. In 1852, he decided to follow an older sister and an aunt who had earlier immigrated to western Pennsylvania. He went to work for a brewer and soon married Elizabeth Sarah Bloedell, who had also emigrated from Weyerhaeuser's hometown. He became acquainted with the sawmill business when he and Sarah moved to the Mississippi River town of Rock Island, Illinois, in 1856.

There, Weyerhaeuser went to work for a sawmill and lumberyard and soon worked his way into managing it. Frugal and industrious, he saved enough money so that he and his brother-in-law, C.A. Denkmann, could buy the company when it fell on hard times during the panic of 1857. He soon bought timberland along the Chippewa River where the logs could be driven down the Chippewa and the Mississippi to his mill at Rock Island. But he found stiff competition for the Chippewa timber, so he teamed up with seventeen other sawmill operators and founded the Mississippi River Logging Company to garner the money necessary to compete.

During this venture, Weyerhaeuser and Denkmann met and became fast friends with lumbermen Peter Musser, William Laird and James and Matthew Norton. Together they formed the Pine Tree Lumber Company and bought thousands of acres of Minnesota timberland. Those acquisitions prompted Weyerhaeuser to move to St. Paul, where he was a neighbor and became a friend of James J. Hill, who owned the Northern Pacific Railroad. It would

# Frontier History Along Idaho's Clearwater River

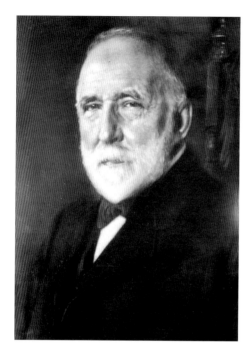

Frederick Weyerhaeuser. *Courtesy of the Library of Congress.*

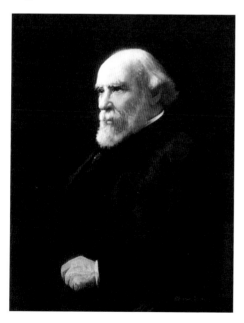

James Hill. *Courtesy of the Washington State Historical Society.*

turn out to be an opportune friendship.

James Hill was born in Ontario, Canada, in 1838. He lost the sight in his right eye in a childhood accident, and his father's death caused him to go to work after only nine years of school. He nonetheless had a real knack for mathematics and land surveying. At the age of eighteen, he had made his way to St. Paul, where he went to work as a bookkeeper for a steamboat company and later as the freight manager for a wholesale grocer. By 1873, Hill was in the steamboat business and then in the anthracite coal business. In the process, he befriended many bankers. When the panic of 1873 hit, he lined up investors to buy the bankrupt St. Paul and Pacific Railroad, which he built into what became the Great Northern Railroad, with a lot of help from his banker and friend, J.P. Morgan.

More important from Weyerhaeuser's perspective was Hill's acquisition of the Northern Pacific Railroad in 1895. The depression of 1893 had put the Northern Pacific in dire financial straits. Through adroit management, Hill had survived the depression, and again with the help of J.P. Morgan, he bought a controlling interest in the Northern Pacific, which

ran to the Pacific Coast parallel to but south of the Great Northern route. Unlike the Great Northern, however, the Northern Pacific had received free alternating sections of land along its route. And where there were Indian reservations or national parks or homesteaders precluding those land grants, the railroad got compensatory land of its choosing from other federally owned land.

Hill, however, was not in the business of becoming a land baron. He had shrewdly calculated that his railroads would prosper only to the extent that there was commerce along their routes to generate cargo for his trains to haul. The free land was also a ready means of raising capital when it was needed, which was often. The railroads sold the available land to buyers by issuing scrip for the number of acres the buyer bought. The buyer could then locate the land it wanted and file the scrip with the United States Land Office, which would then issue title for the identified land.

## The Race to the Land Office

It was the convergence of the vast timberlands available in the West and James Hill's desire to retire $8 million in Northern Pacific debt that led to what is probably the largest private-land transaction to ever occur in the United States. Sitting in Hill's den one night in 1899, Hill told Weyerhaeuser he wanted to sell the nine hundred thousand acres of Northern Pacific land so he could reduce the debt he owed for the railroad. Weyerhaeuser asked him how much he wanted for it, and Hill told him $6 an acre. Weyerhaeuser accepted his offer on the spot. He and his investors bought a third of the scrip, Norton and Laird bought another third and other investors also associated with Weyerhaeuser bought the rest. Overnight, Weyerhaeuser became America's premier timber baron.

But Edward Scofield was the first person to respond to Charles Brown's entreaties to visit Idaho's forests. He sent his son, George, who was also a successful lumberman, and his partner, Warren McChord, to meet with Brown, who showed them around the Clearwater drainage timberland. Scofield either feigned disinterest because of the state's twenty-year harvest limit or wasn't interested at first and changed his mind, but he soon, unbeknownst to Brown, sent McChord and a crew of surveyors and cruisers to the Clearwater to establish boundary lines and determine what land had the best timber.

# Frontier History Along Idaho's Clearwater River

Old-growth white pine at Freezeout Creek. *Courtesy of Clearwater Historical Society.*

At about the same time in 1900, Weyerhaeuser, armed with his Northern Pacific scrip, and John Humbird, who was Weyerhaeuser's partner at a sawmill in Mason, Wisconsin, sent his colleague John Glover and his cruiser James Johnson to meet Brown to assess the potential of the Idaho timberland. By the time the Browns, who were then unaware of their ties to Weyerhaeuser, had shown them the timber around their Bovill homesteads, they were sold. They hired Brown for $150 a month to act as their local agent to scout out available timberland.

McChord had a head start, but his crew had spent much of its time locating the township line. So when Brown started locating section lines, he was able to work off of the survey markers that McChord's crew had already located. Having spent most of his time in Latah County, he was in awe of the forest that graced the south side of the North Fork of the Clearwater River. That summer, a trapper showed Brown, who was now the head cruiser and land buyer for the Weyerhaeuser syndicate, some of the finest timber to be found anywhere from a huge rock with a panoramic view of the Clearwater drainage. Nat Brown recounted his father's reaction:

> *I later took my father to this location and he named the rock Brown's Rock. Brown's Rock was approximately one and one-half miles west of the point where a lookout tower was built (Brown's Rock) in 1934. It was a good viewpoint where you could see Washington, Scofield and Beaver Creeks. It was here that my father stood on top of the rock and spread his arms wide and said, "We will select all the good timber that can be seen from this rock to be ours."*

## The New Bonanza

Brown soon discovered, to his dismay, that McChord had the jump on him. He mobilized a crew of his son, Nat, Theodore Fohl, four crewmen and himself to locate the lines for and cruise the timber that C.O. Brown had seen that day he stood atop Brown's Rock. They worked every daylight hour identifying and locating the land they wanted to buy. Brown telegraphed Glover to rush to Lewiston so they could file the scrip for the land he had selected. Glover arrived at Lewiston, raced to the United States Land Office and filed scrip for thirty thousand acres of Idaho's most valuable timberland. McChord would discover the next day that he was a day late.

That set off a frenzied scramble to get the land that adjoined what the Weyerhaeuser syndicate had just recorded at the land office. Brown's exhausted crew returned to locate and cruise the land that Glover had not filed on. On September 24, 1900, Brown learned that McChord's man had left for Lewiston to file on the additional prime forestland. Brown sent Nat to overtake McChord's man. Keith Petersen, in his book *Company Town*, described the epic race to the land office:

> *McChord's man had a three-hour start, but Nat, with an excellent horse, a sack of oats, a small lunch, and a "palouser"—a lard pail with a candle stuck through a jagged side hole to provide light—rode after him into the night woods. After twenty-five miles Brown came to a lighted cabin. Extinguishing the lighted palouser, he stealthily approached the window and found McChord's man resting inside. Creeping to the barn, Brown discovered two horses. One was wet and covered with mud, exhausted from a hard ride through the forest. The other was fresh. He saddled the fresh one, turned his own and the tired one loose, and hastened into the woods, reaching Orofino before dawn, where he found a waiting railroad engine. When asked if he had requested the engine for a special run to Lewiston [that McChord had in fact requested], Nat replied that he was indeed heading for that town. Having stolen a horse and commandeered a train, Brown once again beat McChord to the land office, and on September 25 Glover filed on an additional 20,000 acres.*

In October, Frederick Weyerhaeuser; his son, Charles; and John Humbird, accompanied by Glover, came to Idaho to inspect their newly acquired land. They were overwhelmed at its quality. These fifty thousand acres became the main asset of the Clearwater Timber Company, which they organized in November 1900 at the Pioneer Hotel at Pierce City. Humbird was elected its first president, Frederick Weyerhaeuser its vice-president, Glover its

secretary and Nat Brown its local agent. It had a capitalization of $500,000 and would eventually acquire more than two hundred thousand acres of one of the finest stands of timber in the country.

## HERE COME THE LUMBERJACKS

In 1903, just three years after Clearwater Timber Company bought its land in the Clearwater drainage, Weyerhaeuser's son, Charles, and his partners in the Pine Tree Lumber Company, who included William Laird's son, Allison Laird; Matthew Norton; and Peter Musser's son, Drew Musser,

William Deary. *Courtesy of Latah County Historical Society.*

# The New Bonanza

incorporated the Potlatch Lumber Company. The Pine Tree Lumber Company had just got its Minnesota mill going when the depression of 1893 hit the country. Weyerhaeuser and Musser ran the Pine Tree Lumber operation, and they struggled through the depression and were frugal in everything but buying timber, which their fathers had taught them usually paid off. In the process, they met William Deary, a Minnesota timber speculator from whom they bought substantial tracts of Minnesota timberland. He made a big impression on them, and he would play a transforming role in their economic lives.

Born in Quebec in the 1850s, Deary was a remarkable man—a short, stout, barrel-chested Scotsman, an accomplished logger and an expert woodsman whose cruise figures usually proved out. But he was much more than that. He was an aggressive go-getter and visionary who was never daunted by a challenge, never lacked for energy and never let a good opportunity pass him by. So it was to Deary that Weyerhaeuser and Musser turned when trying to decide whether to expand their logging ventures to the south or the west.

After looking at timber in Alabama, Louisiana and Texas, Deary was skeptical that the West would be a better bet. He nonetheless traveled to Idaho in 1900, only to find that Clearwater Timber Company had filed on timberland in the Clearwater drainage. He spent only a couple of days in Lewiston and apparently didn't venture very far into the woods and remained skeptical. But later that year, C.O. Brown persuaded Frederick and Charles Weyerhaeuser to come to Idaho and see the timber for themselves. They extensively scouted out the timber and were convinced the West was the better choice. They eventually convinced the Pine Tree Lumber Company directors that Idaho had a better logging future than either the South or Minnesota. After a more thorough appraisal of the Idaho timber stands, Deary came around and became the spark plug of the undertaking. Historian Peterson's *Company Town* relates the sequence of events that followed.

The first thing Deary did was to team up with his fellow Canadian William Helmer, who was an even more astute cruiser than he was. They were a great pair. They had their love of the woods in common, and their deftness as cruisers was legendary. But physically, they were like a sapling and a stump. Deary was short; Helmer was tall. Deary was stout; Helmer was lanky. Deary at times would put 250 pounds on his five-foot, nine-inch frame, while Helmer was as thin as a rail. Deary was mercurial; Helmer was reserved. But one thing Deary knew for sure: when Helmer gave him a cruise figure, he could take it to the bank.

William Helmer. *Courtesy of Latah County Historical Society.*

Once the Potlatch Lumber Company decided to build a sawmill, the Moscow city fathers lobbied Deary to locate it there. Deary knew that unless he built a railroad, the Palouse River was the only way to get the number of logs needed for the size of mill he had in mind. Tact was not one of Deary's strong traits. Local lore, according to early-day Bovill resident Robert Denevan, has it that Deary told the city fathers that even in a hard rain, Moscow didn't have enough water to baptize a bastard. So, instead of Moscow, Deary chose the confluence of Rock Creek and the Palouse River as the site for the sawmill, and the company built the town that would become Potlatch.

Deary got the operation off to a quick start. First he needed logs for the mill. The state had selected much of the Latah County timber as state land and had imposed a twenty-year harvest deadline to discourage speculative buying. That posed a problem for Deary because the capital investment in the mill and town couldn't be justified for just twenty years of operation. So he devised a two-pronged plan. He would buy what private land he could and collude with other buyers to buy the state stumpage.

## The New Bonanza

## The Battle for the Palouse Timber

Already operating on the Palouse River were the Palouse River Lumber Company at Palouse City and the Codd Lumber Company at Colfax. George Peddycord owned the Palouse River Lumber Company, which had an operating mill, a planer, a molding factory, a large warehouse, a contract to supply lumber for the construction of Washington State College and, most importantly, valuable timberland that Bill Helmer concluded had been underestimated by an earlier prospective buyer. Peddycord proved to be a tough negotiator. He brusquely rejected the first offer of $100,000, and a deal was ultimately reached for $265,000, a figure that stunned the Potlatch Lumber Company directors.

Next in Deary's sights was the sawmill that William Codd had operated at Colfax since 1877. Codd proved to be a pain in Deary's neck and in another part of his anatomy farther south. Codd had a good business supplying fruit boxes for the orchards along the Snake River. But he wasn't cast in the mold of the turn-of-the-century capitalists. He regularly outbid Potlatch Lumber on stumpage sales so he could run his mill at full capacity. Even more, he made a reality out of Deary's worst nightmare: he allowed his employees to unionize and paid them better wages than Deary, which led to a strike by Potlatch Lumber employees in 1903. As if that weren't enough, Codd also

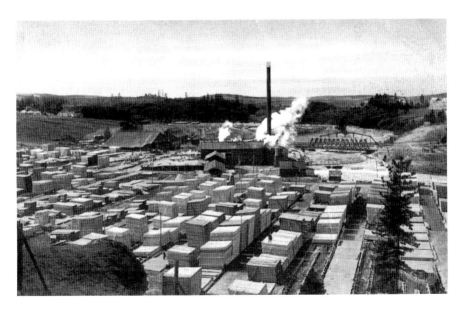

Palouse River Lumber Company sawmill. *Courtesy of Don and Teresa Myott.*

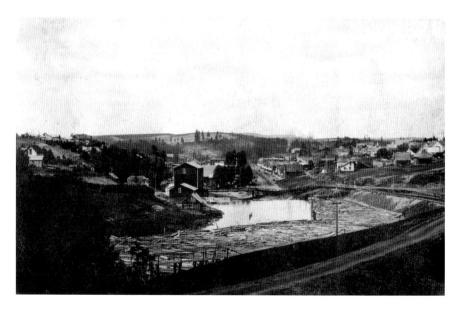

Palouse River log drive. *Courtesy of Don and Teresa Myott.*

had four aces in his hand—the preemptive right to the use of the Palouse River for his log drives. Deary would learn that he had met his match.

In the spring of 1903, Codd deliberately waited to start his log drive until after Deary started his to supply the Peddycord mill he had bought at Palouse City. That forced Deary to sort the logs at Palouse City at considerable cost and effort so Codd's logs could enjoy their senior right to float down the Palouse River. Deary soon realized that in order to be comfortable while sitting, he was going to have to ante up, and he did—at a price of $115,000. Deary got the Colfax mill, timberland and Codd's rights to use the Palouse River. Codd got his price at a more than considerable profit.

The second prong of Deary's strategy was to buy as much state stumpage as he could for as little money as he could. But a competitor was also bidding at the sales. Henry Turrish represented the Wisconsin Log and Lumber Company, of which Warren McChord, whom C.O. Brown had outwitted in the Clearwater timber sales, was a principal. Deary and Turrish soon reached an understanding that would inure to their mutual benefit. One would buy and then share the stumpage with the other. Other parties eventually became a part of the scheme, and by the time the sales were over, Potlatch Lumber had the rights to forty thousand acres of state stumpage in Latah County.

Deary now had the stumpage, lumber and railroad ties he needed to get the mill-built, company-owned town started. Deary oversaw the construction

# The New Bonanza

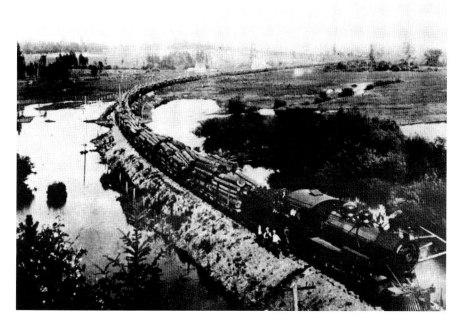

WIM Railroad train hauling logs to the mill at Potlatch. *Courtesy of Latah County Historical Society.*

of the town and the large, single belt–driven line shaft sawmill. The mill had a sixty-acre lumberyard, thirty miles of track, a single-cylinder steam engine with a 1,200- to 1,800-horsepower range, a mill with a daily capacity of 700,000 board feet of lumber, a sorting shed 540 feet long and a planing shed 400 feet long. Despite Deary's singular accomplishments, he still was not satisfied.

Railroads were transforming America, and Idaho was no exception. Bill Deary knew that railroads were far more reliable and adaptable than the Palouse River for transporting logs to the sawmill at Potlatch. Trains could haul logs up a hill as well as down, and a rail line could be built to where it was convenient to log rather than having to log where it was convenient to the river. And, more importantly, it made it physically and financially feasible to log beyond the Palouse River drainage to supply the Potlatch mill.

Deary decided to build a forty-eight-mile common carrier railroad to Warrens Meadows, which he named the Washington, Idaho and Montana Railroad. That would give him access to the Clearwater's North Fork drainage timber. Everything went smoothly until he reached Hugh Bovill's

homestead. Bovill was the youngest of sixteen children born to an English lord. Knowing that only the oldest son could inherit the family estate, he and his wife, Charlotte, found their way to Warrens Meadows, where they ran a hotel and hunting lodge on the large meadow that skirted the pristine Potlatch River. The beauty of the setting was matched only by the sumptuous hospitality that greeted their guests. Linen tablecloths, crystal glasses and silver utensils were a given. So they were not happy about a railroad intruding on their splendid isolation.

It took a lot of haggling and even more money to persuade Bovill to sell a right-of-way through his homestead, but he finally relented to the inevitable commercial development of the region. He and Charlotte would remain and give their name to the town that would be built on the land they had once cherished.

The circumstances that give rise to towns are as varied as the towns themselves. The town of Elk River owes its existence to a freak of nature—an epic windstorm. In May 1908, Charles Weyerhaeuser and John Humbird decided to explore the timber east of Bovill as far as Elk Creek and then beyond there to the North Fork. They discovered a huge recent blowdown of timber that cruiser Bill Helmer estimated to be about ten million board feet of high-quality white pine. If they were going to salvage the windfall, they were going to have to move with dispatch. And move quickly they did.

The only homesteader on Elk Creek at the time was W.W. Trumbull, who had settled there in 1897. By 1909, Trumbull was running a way station and a hunting lodge on the big meadow at Elk Creek and had acquired about four thousand acres of timberland. As was his wont, Deary took charge. First, he bought Trumbull's entire holdings. Then, he cajoled the Chicago, Milwaukee and St. Paul Railroad to extend its line from St. Maries to tie in with the Washington, Idaho and Montana Railroad at Bovill and then from Bovill another twenty-some miles to Elk Creek. With the prospect of having freight from two major sawmills, it probably wasn't a hard sell.

# Green Gold

Deary next hired a contractor from Bonners Ferry to start on a foundation for a new mill about seventy miles from the Potlatch mill he had just finished building. Deary had also lured Charles Munson away from his job as state land commissioner to be the logging boss for Potlatch Lumber Company, so he went in with a crew and started building a dam for the millpond so the

Clearwater lumberjacks. *Courtesy of Latah County Historical Society.*

mill would have a log inventory by the time it started up. Once the pond was in, Munson hired 250 lumberjacks. The sawyers put their crosscut saws to work, and the teamsters put the horses to work, and they filled the pond with logs from the blowdown.

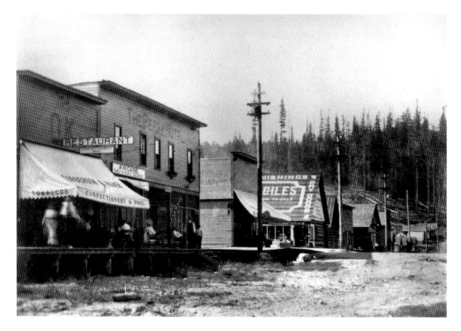

Town of Elk River. *Courtesy of Richard Pomponio Sr.*

The steam-driven single-belt mill at Potlatch was obsolete almost as soon as it was built. The mill at Elk River was destined to be a state-of-the-art electric mill that could compete with any in the country. Not only was the mill electrically powered, there was electricity in the air. In July 1911, the *Elk River Sentinel* reported:

> *The upbuilding of Elk River has been a marvel indeed. Not more than a year ago the site of the present town was a thick forest and was then held as a homestead, since then the land has been cleared, the stumps removed and large substantial town build up containing imposing and commodious stores and residence structures.*

The article left no doubt about the town's future. It continued:

> *The railroad is completed. The sawmill, with a daily output of 300,000 feet, is finished and operating with two shifts to its full capacity. There are over 1000 on its payroll. Elk River has grown in one year from naught to a population of 1300 and the end has not come indeed. Every kind of business is represented in the town and the mercantile stores, about forty in number, have assumed a truly metropolitan appearance.*

# The New Bonanza

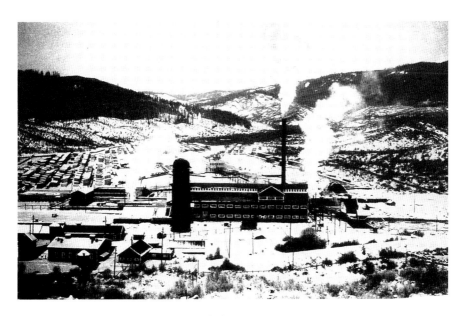

Elk River sawmill. *Courtesy Richard Pomponio Sr.*

And Elk River truly did become quite a town. It boasted a hospital, a bank, the *Elk River Sentinel* newspaper, a modern primary and high school building with a gymnasium, pool halls, boardinghouses, an office building and a large general store that was owned by Ralph Wagner, who later sold the store to Leonard Foster. Carl Jockek ran the butcher shop, and he slaughtered and butchered the animals in the back of the shop. Merle Deneven and Greek immigrant Tom Scondoras ran the Dream Theater. George and Oscar Torgerson ran the dray operation and mined on Swamp Creek. And Archie Little was the local farrier. Archie wouldn't accept money for shoeing the horses, but he was known to accept a gallon or two of bootleg whiskey, depending on the size of the job. Two husky Serbian brothers, Bob and Tom Gotch, were active in the Industrial Workers of the World, a militant union that was commonly known as the Wobblies, and they were tough enough that you gave them guff at your peril. Elk River was, in sum, a bustling and vibrant mill and logging town.

The miners were long gone. The lumberjacks had arrived. And a new bonanza was underway. And so it was in the early days of the Clearwater, when whiskey was sold by the gulp and timberland was sold for six bucks an acre.

# BIBLIOGRAPHY

Bailey, Robert G. *River of No Return*. Lewiston, ID: R.G. Bailey Printing Company, 1947.

Bancroft, H.H. *History of Washington, Idaho and Montana*. San Francisco: History Co., 1890.

Beal, Merrill, and Merle Wells. *History of Idaho*. New York: Lewis Historical Publishing Company, Inc., 1959.

Bird, Virginia E. *Patrick and Bridget Gaffney and Their Descendants*. Self-published, 2005.

Birney, Hoffman. *Vigilantes*. Philadelphia: Penn Publishing Company, 1929.

Cannell, Lin Tull. *William Craig Among the Nez Perce*. Carlton, OR. Ridenbaugh Press, 2001.

Chen, John. *Chinese in America*. San Francisco: Harper and Row, 1980.

"Clearwater Gold Rush." *Idaho Yesterdays* (Spring 1960).

Curtis, A.B. *White Pines and Fires*. Moscow: University of Idaho Press, 1983.

Defenbach, Byron. *The State We Live In*. Caldwell, ID: Caxton Printers, Ltd., 1933.

# Bibliography

Donaldson, Thomas. *Idaho of Yesterday*. Caldwell, ID: Caxton Printers, Ltd., 1941.

Dryden, Cecil. *The Clearwater of Idaho*. New York: Canton Press, 1972.

Farbo, Tom. *White Pine, Wobblies and Wanigans*. Lewiston, ID: Steeley Printing, 1996.

French, Hiram T. *History of Idaho*. New York: Lewis Publishing Company, 1914.

"Gold in 1860: Newspaper Reports of the Pierce Gold Strike." *Idaho Yesterdays* (Fall 1959).

Goulder, W.A. *Reminiscences*. Boise, ID: Timothy Regan, 1909.

Greenwald, Emily. *Reconfiguring the Reservation*. Albuquerque: University of New Mexico Press, 2002.

Hailey, John. *History of Idaho*. Boise, ID: Syms-York Company, Inc., 1910.

Hawley, James H. *History of Idaho: The Gem of the Mountains*. Chicago: S.J. Clarke Publishing Company, 1920.

*History of North Idaho*. Boise, ID: Western Historical Publishing Company, 1903.

"Idaho in 1860: Those Were the Days." *Idaho Yesterdays* (Spring 1960).

Lewis, William S. *Reminiscences of Joseph H. Boyd*. Seattle: University of Washington Press, 1924.

Lundstrom, W.G. "Early Idaho Crimes" manuscript. Lewiston, ID: Nez Perce County Historical Society, n.d.

McConnell, William J. *The Early History of Idaho*. Caldwell, ID: Caxton Press, Ltd., 1913.

McWhorter, L.V. *Hear Me, My Chiefs! Nez Perce Legend and History*. Caldwell, ID: Caxton Printers, Ltd., 1952.

# Bibliography

Molloy, John T. "Passing of the Pioneers" manuscript. Orofino, ID, 1930.

Mossman, Isaac. *A Pony Expressman's Recollections*. Portland, OR: Champoeg Press, 1985.

"News from Nez Perce Mines." *Idaho Yesterdays* (Winter 1989–1990).

Peterson, Keith. *Company Town*. Pullman: Washington State University Press, 1987.

Shattuck, Louise. *Doctors with Buggies, Snowshoes, and Planes*. Boise, ID: Tamarack Books, Inc., 1993.

Shoshone County court records. Orofino, ID: Clearwater Historical Museum, 1861–85.

Simon-Smolenski, Carole. *Idaho's Chinese Americans, Idaho's Ethnic Heritage*. Boise: Idaho Centennial Commission, 1990.

Spencer, Layne Gellner. *And Five Were Hanged*. Spokane, WA: Remax Printing and Awards, 1968.

Stapp, Darby Campbell. "The Historic Ethnography of a Chinese Mining Community in Idaho." Doctoral thesis, University of Pennsylvania, 1990.

"Town of Potlatch, Idaho to Be Made a Model by the Company." *White Pine Route Quarterly*, vol. 13, no. 3, February 1, 2012, quoting *Spokesman-Review* article dated May 13, 1906.

Trull, Fern Cobble. "The History of the Chinese in Idaho from 1864 to 1910." Master's thesis, University of Idaho, 1946.

Warren, Harry. Untitled manuscript. Lewiston, ID: Nez Perce County Historical Society, 1960.

Williams, J. Gary, and Ronald W. Stark. *The Pierce Chronicle*. Moscow: Idaho Research Foundation, Inc., 1975.

# ABOUT THE AUTHOR

John Bradbury was born in Orofino and reared in a logging town twelve miles north of Pierce City, now known as Pierce. He graduated from the University of Idaho and the University of Michigan Law School and then served with the Eighth Army at Inchon, Korea. After practicing maritime law for twenty-five years at Seattle and Anchorage, he retired back to Idaho, where he taught at Lewis-Clark State College for several years as an adjunct professor. He currently serves on the boards of the Clearwater Historical Society and its museum at Orofino and the Northwest Children's Home at Lewiston. He divides his time between Lewiston and the family homestead at Fraser.

*Visit us at
www.historypress.net*

*This title is also available as an e-book*